Pontormo

PORTRAIT OF A HALBERDIER

Elizabeth Cropper

GETTY MUSEUM
STUDIES ON ART
—————
LOS ANGELES

Christopher Hudson, *Publisher*
Mark Greenberg, *Managing Editor*

William Peterson, *Editor*
Elizabeth Zozom, *Production Coordinator*
Jeffrey Cohen, *Designer*
Lou Meluso, *Photographer*

© 1997 The J. Paul Getty Museum
1200 Getty Center Drive, Suite 1000
Los Angeles, California 90049-1687

Frontispiece:
Pontormo (Jacopo Carucci) (Italian, 1494–1557).
Self-Portrait Study, circa 1525. Red chalk.
London, The British Museum (1936.10.10.10r).
Copyright © British Museum.

All works of art are reproduced (and photographs
provided) courtesy of the owners, unless otherwise
indicated.

Typography by G&S Typesetters, Inc.,
Austin, Texas
Printed in Hong Kong by Imago

CONTENTS

Final page folds out,
providing a reference color plate of
Portrait of a Halberdier

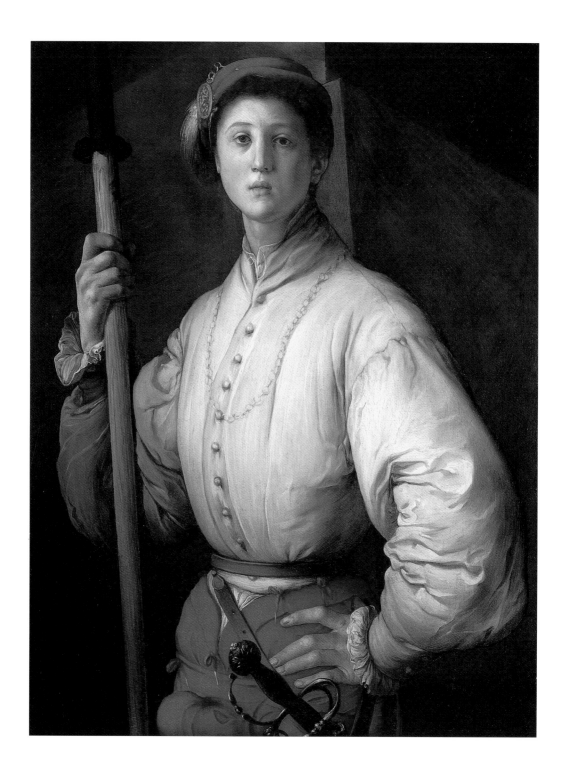

INTRODUCTION

When a great painting is the subject of intense study, interpretive possibilities proliferate as we change our point of view in the historical landscape, standing up close or taking a distant look. Nowhere is the challenge of such shifting focus more powerful than in the study of portraits. In the earliest Renaissance treatise on painting Leon Battista Alberti wrote of the ancient conviction that portraits keep the dead alive, and we do often look upon them as our window into the past. Yet even the most literal images—death masks in plaster or wax—cannot answer many of our questions. Who *was* he? What was she *like*? Every artist has unique ways of representing *likeness*, and every culture has its own hierarchy of values to be commemorated. And yet it is often tempting to look at a portrait with instant sympathy: "Yes, I *know* what he must have been like," we want to say; or, "I would recognize her today!"

The evoking of such a response was one aim of the naturalistic paradigm for portraiture that prevailed in Italy around 1500. It was not, however, the model followed by the Florentine painter Pontormo (Jacopo Carucci, 1494–1557) in his mature work. While his portraits are highly naturalistic in detail, they are also conspicuously marked by a distinctive and self-conscious personal style. The discovery of such personal style by artists of his generation in Italy was intensely bound up with the evolution of new styles of comportment, or, what we call manners. The cultivation of bodily grace, verbal wit, courtly politeness, and cautious privacy, as described by such contemporary writers as Baldessare Castiglione in his *Book of the Courtier* (1528), or by Giovanni della Casa in his *Galateo* (1558), involved a new kind of dissimulation, or what Stephen Greenblatt has called self-fashioning. As the social importance of appearances increased, so too did self-observation, and to dissimulate for the purposes of good manners and civilized behavior was not viewed as hypocritical, but rather as socially desirable. The resulting combination of artifice and dissimulation, and the value attributed to appearance as opposed to strict resemblance on the part of both a sitter and his painter, makes thinking about a portrait produced under these conditions all the more problematic.

This short book on the portrait of a young man by Pontormo [FIGURE 1, FOLDOUT] is intended as an introduction to the questions such paintings provoke, and

Figure 1
Pontormo (Jacopo Carucci) (Italian, 1494–1557). *Portrait of a Halberdier,* 1529–30. Oil on panel transferred to canvas, 92 × 72 cm (36¼ × 28⅜ in.). Los Angeles, J. Paul Getty Museum (89.PA.49).

to the ways in which historians try to answer them. When the picture was acquired by the J. Paul Getty Museum from the estate of Chauncey D. Stillman in 1989, it was identified as a portrait of Cosimo I de' Medici, duke of Florence.[1] That identification is questioned here, and I will propose instead that the sitter is Francesco di Giovanni Guardi. Not all of the arguments in favor of this proposed identification will be conclusive. At times they will be quite complicated, and they may occasionally seem more like presentations made in a court of law rather than commentary intended to enhance the appreciation of a work of art. But much of what has been said about this painting in the past is incorrect and much of the evidence assembled here is new. In the end I hope that Pontormo's portrait of a young man will be even more compelling than on first encounter. As Luciano Berti, until recently the *Sorprintendente delle Belle Arti* for Florence, has said, although the Getty Museum may not have purchased a portrait of Cosimo I, it most certainly did acquire an authentic masterpiece.[2]

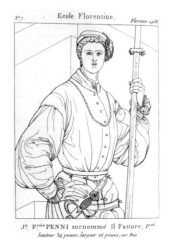

No. 7. Ecole Florentine. *Florence 1488*

J°. F°ᶜⁱˢ PENNI surnommé Il Fattore, *P.ʳᵉ*
hauteur 34 pouces, largeur 26 pouces, sur Bois

Figure 2
Pontormo. *The Halberdier.* Engraving by Jean-Baptiste-Pierre LeBrun (French, 1748–1813). From Jean-Baptiste-Pierre LeBrun, *Recueil de gravures au trait* (Paris, 1809), plate 7.

PROBLEMS

Nothing is straightforward about our portrait. Even the question of authorship was resolved only in 1920, when Hermann Voss attributed the work to Pontormo definitively. In a catalogue prepared in 1809 by J.-P.-B. LeBrun of paintings he had collected for sale, our portrait is attributed to the Florentine painter Giovanni Francesco Penni, a member of Raphael's workshop [FIGURE 2]. In this, the first publication of the picture, the portrait is correctly described as coming from the Riccardi collection in Florence. It then passed through several other French collections, where it was attributed to a variety of other artists. At some point, probably when it was in the Bonaparte collection, the painting was transferred from its original wooden panel to canvas.[3]

The title by which the work came to be known—*Portrait of a Halberdier*—was coined by Frank Jewett Mather only in 1922, after the portrait had been brought to the United States. "So clearly has the artist seen the universal soldier in this young Florentine," wrote Mather, "that we should lose something if we knew his name and lot as an individual."[4] Yet it seems impossible not to ask who this young man is, and why and where Pontormo painted his portrait. Is this truly a portrait at all, or is it, as Mather wanted it to be in the aftermath of the Great War, "the Platonic idea of the soldier on

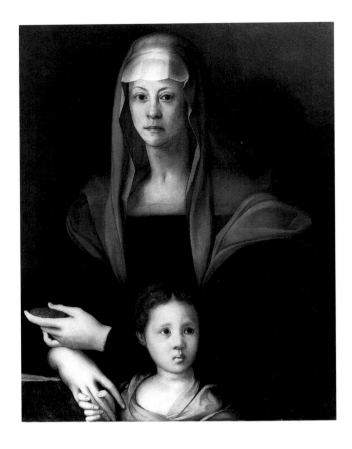

Figure 3
Pontormo. *Portrait
of Maria Salviati with a
Child*. Oil on panel,
88 × 71.3 cm (34⅝ ×
28⅛ in.). Baltimore,
The Walters Art Gallery
(37.596).

Duty . . . a type for the splendor of military loyalty, for all youth that has looked wide-eyed and fearless upon peril, for all beauty that has offered itself for annihilation, or worse, for mutilation," in which Pontormo sensed "the whole terrible and splendid oblation that all generous youth at all times has made to love of country"? The question of identity is, moreover, closely linked to the problem of the date of the portrait, for which, as for most portraits of the time, we have no secure documentation.

Complicating the question is the association of the *Halberdier* with another portrait by Pontormo [FIGURE 3], now in the Walters Art Gallery, Baltimore. In 1959 Herbert Keutner made the bold suggestion that these two paintings represent, respectively, the young Cosimo de' Medici, ruler of Florence, and his mother, Maria Salviati. He further proposed that they are the very portraits mentioned by Pontormo's biographer Giorgio Vasari as having been painted shortly after the Battle of Montemurlo, in which, on the night of 31 July 1537, Cosimo decisively defeated the group of powerful

Florentine exiles who wanted to reinstate the republic. At this moment the young duke was eighteen years old.[5]

The Baltimore portrait was itself already the center of a debate. The child had at some point been painted out, and was only revealed by cleaning in 1937. In 1940 Edward King identified the sitter as Maria Salviati, the granddaughter of Lorenzo the Magnificent, widow of Giovanni delle Bande Nere, and mother of Cosimo I. The child he identified as young Cosimo himself. But is this a portrait of Maria in mourning, holding a (now illegible) medal of her husband Giovanni delle Bande Nere and painted on the occasion of his death fighting against the emperor Charles V in 1526? Or is it rather a retrospective work, painted in 1537 after the child had become Cosimo I, duke of Florence? In which case, could it indeed be the portrait of Maria Salviati that Vasari reports Pontormo to have made, together with one of Cosimo, at about that time, even though he mentions no child in the portrait of Maria?

In 1941, in a private response to King's article, Bernard Berenson noted acerbically that "the prodigiously learned gentleman who wrote on the Pontormo portrait makes a serious mistake in the sex of the child. This is certainly a girl and therefore not the *boy* destined to become Cosimo I."[6] The Walters portrait is quite damaged, especially in the lower register, and the age of the child makes it difficult to be certain of its sex. But if Berenson was right, should we instead conjecture that Maria Salviati may be portrayed here around the time Cosimo became duke, but that she is shown with one of her female grandchildren? Or is it more likely that the girl is Giulia, the daughter of Cosimo's cousin and predecessor, Duke Alessandro de' Medici, with whose safekeeping Maria had been entrusted after the assassination of the child's father in 1537? Or, to name still another possibility, could this ghostly image be a posthumous portrait of Maria, painted from a mask made on her death in 1543? In which case, does it perhaps commemorate her in a retrospective way, accompanied by her son Cosimo as a small boy, as if at the time of his father's death? All these proposals have been made, and posthumous ancestral portraits were indeed much favored by Cosimo as he created an iconography to support the claims of his dynasty.

Keutner's suggestions, however, were based on important new evidence, namely an inventory, dated 1612, of the Riccardi collection in Florence. This document not only made it possible to establish an unbroken provenance for the Getty portrait from 1612 to the present, but it also appeared to confirm the artist and his subject. In the inventory the picture is described as follows:

A portrait of similar height [i.e., to a portrait by Rosso Fiorentino listed as one and one-quarter *braccia* high], believed to be by the hand of the said Jacopo [the preceding entry is for a portrait of a woman by "Jacopo da Puntormo"] of the Most Excellent Duke Cosimo when he was a young man, with red breeches, and a red beret, and a pike in his hand, with a sword at his side, and a white doublet, and a chain around his neck, with a very beautiful gilded frame.[7]

Earlier in the same list appears the portrait of Maria Salviati now in Baltimore, described in a way that would have satisfied Berenson: "A painting of one and one-half *braccia* of Signora Donna Maria Medici with a baby girl [*una puttina*], by the hand of Jacopo da Puntormo."[8]

Keutner's theory that the Getty and Walters portraits were in fact pendants is challenged by this early identification of the child as a girl. For if Maria Salviati is not shown with her infant son, and possibly holding a medal commemorating her dead husband, then her portrait cannot be quite so tightly bound to the Getty portrait, in which Keutner believed that the same son appeared, fulfilling his destiny. Whether or not these are the 1537 portraits referred to by Vasari remains open to question.

Some of the problems surrounding our portrait, however, do appear to have been solved by Keutner's discovery: the *Halberdier* must be a portrait of Cosimo I de' Medici holding a pike, and painted by Pontormo. It could date to around 1537, but no later than that, for the sitter is beardless. In Bronzino's *Cosimo de' Medici as Orpheus*, dating from the time of Cosimo's marriage to Eleonora of Toledo in 1539, Cosimo wears a very short beard, as he does in medals from 1538 on.

Identification of the subject of the Getty portrait remained nevertheless problematic to many scholars. In Cosimo's earliest commemorative medals, in which he has no beard, the duke's features—especially the bony and slightly hooked nose, bulging eye, and pronounced chin— closely resemble the strongly outlined profile in a black-chalk drawing [FIGURE 4] made by Pontormo during Cosimo's first months in power. This profile also resembles that of his father, as recorded in the portrait that Titian was commissioned to paint after a death mask. Yet there are clear physiognomic differences distinguishing the drawing from the Getty portrait: the pronounced jaw, the prominence of the bony nose, the

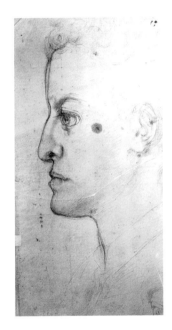

Figure 4
Pontormo. *Study for a Portrait of Cosimo I de' Medici*, 1537. Black chalk, 42.1 × 21.5 cm (16⅝ × 8½ in.). Florence, Galleria degli Uffizi (6528Fv).

5

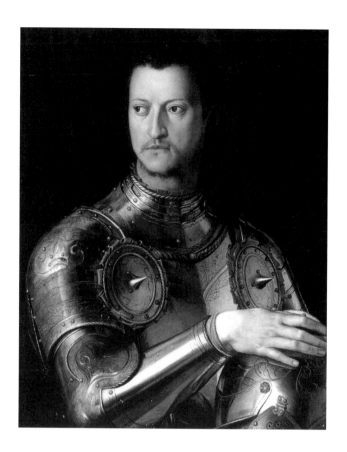

Figure 5
Bronzino (Angelo di
Cosimo di Mariano)
(Italian, 1503–1572).
*Portrait of Cosimo I de'
Medici in Armor*, 1545.
Oil on panel, 74 ×
58 cm (30⅜ × 23⅝ in.).
Florence, Galleria
degli Uffizi. Photo: Canali
Photobank, Italy.

thinness of the upper lip, the largeness of the eye, and the definite downward turn of the
inner edge of the eyebrow are features recorded in the drawing that find no counter-
parts in the *Halberdier*.[9] Moreover, Cosimo I de' Medici very early adopted an official
portrait and an official portrait painter. It is hard to see Pontormo's young man, with
his curly locks, his delicate straight nose, pronouncedly fleshy lips, and his pointed
chin, as the precursor of the stern figure—seemingly squarer of jaw, his mouth more
straight-set, and hair already receding—who appears in Bronzino's *Portrait of Cosimo I
de' Medici in Armor*, of 1545 [FIGURE 5]. This is the portrait that would fix the image of
Cosimo for posterity. Perhaps more easily assimilated to the youthful image portrayed
by Pontormo, as Kurt Forster first proposed, are various images of Cosimo by Baccio
Bandinelli. The resemblances are not close, however, and in all the comparisons pro-
posed Cosimo wears a beard.

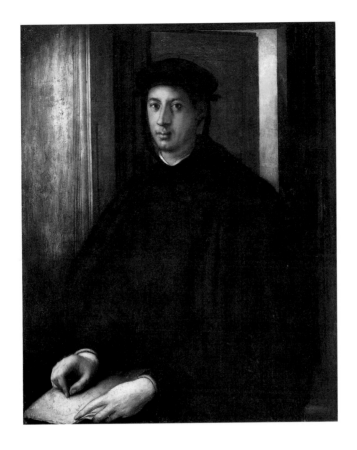

As he consolidated his power, the young duke wanted to be recognized in every possible kind of imagery. And so, if the Getty portrait does represent Cosimo, we are justified in asking why he is not more recognizable in this, the first image of his manhood. Why would a young man assuming political power for which his only credentials were his ancestry and his personal honor have had himself portrayed so ambiguously, and without precise, identifying attributes? After all, around 1519 when Pontormo was commissioned to paint a posthumous portrait of the revered Medici paterfamilias Cosimo il Vecchio, a man he had never seen, he produced a work so loaded with Medicean imagery there was no mistaking him. Nor would we have any difficulty, even without Vasari's help, in identifying the sitter in Pontormo's *Portrait of Alessandro de' Medici* [FIGURE 6] as Cosimo's ill-fated cousin, the first duke of Florence: his appearance is unmistakably consistent with other portraits of him.[10]

Figure 6
Pontormo. *Portrait of Alessandro de' Medici*, circa 1534–35. Oil on panel, 100.4 × 81.3 cm (39½ × 32 in.). Philadelphia Museum of Art, The John G. Johnson Collection (83).

The strongest counterargument to Keutner's identification has been put forward by Luciano Berti, following an earlier proposal by Voss. Where others began with Vasari's mention of a portrait of Cosimo, Voss identified the *Halberdier* with another portrait that Vasari described in his account of Pontormo's life:

AT THE TIME OF THE SIEGE OF FLORENCE
HE ALSO PORTRAYED
FRANCESCO GUARDI IN THE COSTUME OF A SOLDIER,
WHICH WAS A MOST BEAUTIFUL WORK.
AND ON THE COVER OF THIS PORTRAIT
BRONZINO PAINTED PYGMALION PRAYING TO VENUS
THAT HIS STATUE,
RECEIVING BREATH, WOULD COME ALIVE.[11]

The argument has a great deal to commend it: the sitter is clearly "dressed as a soldier," which is not quite the same as *being* a soldier, as we shall see. Vasari's account would date the Getty portrait to 1529–30, the time of the siege of Florence, a date that would be impossible for a portrait of the ten-year-old Cosimo de' Medici, who was born in 1519, but one that is very attractive on stylistic grounds. It places the portrait soon after Pontormo's work in the Capponi Chapel in Santa Felicità [see FIGURE 7], and close to the *Martyrdom of the Ten Thousand* [see FIGURE 22], in which figures with similar facial characteristics and proportions appear.

One of the chief obstacles to Voss's proposal had been that the only Francesco Guardi known to history was born in 1466; but Alessandro Cecchi's discovery of a Francesco Guardi born in 1514 (published by Berti) removed the block. This Francesco Guardi would have been about sixteen at the time of the siege—an age that is consistent with the *Halberdier*'s luminously youthful complexion and adolescent strength. Among other Florentines portrayed by Pontormo around this time, Vasari also lists Carlo Neroni, who was born in 1511, and Amerigo Antinori, born in 1516.[12] The latter was in fact to become a famous soldier, and Vasari recalls him as "a young man very much in favor at the time." But Vasari's report that the Antinori portrait led to Pontormo's commission to paint Duke Alessandro [see FIGURE 6] would imply a date after 1530. Vasari's most detailed and promising description remains that of the portrait of Francesco Guardi, made "at the time of the siege."

A second obstacle to the identification of the *Halberdier* as Francesco Guardi has been Vasari's further comment that Bronzino's *Pygmalion and Galatea* [see FIGURE 47] was painted as a cover for the portrait of Guardi. The *Pygmalion and Galatea* measures 81 by 63 cm today (and was at one time slightly smaller), whereas the *Halberdier* now measures 92 by 72 cm. As a result, several scholars, beginning with Mather in 1922, concluded that the former could not have served as a cover for the latter, and that the *Halberdier* could not therefore be the portrait of Guardi in question, which was presumed to be lost. However, there are too few examples of portraits surviving together with their covers for us to be sure how the two might have been put together in this case, and their present difference in size is not enough to deny a relationship a priori.[13] One can, for example, easily imagine how the difference in measurements could have been made up for by a framing device, especially as the proportions are the same, with a difference of roughly 11 cm in both the vertical and horizontal dimensions.

In the identification of the sitter of the Getty portrait much is at stake. The issue is not merely a question of giving a name to a face, but of radically different and incompatible interpretations of this image, one of the most original of its time. And conversely, how we identify the sitter alters our view of those times. Berti, as much affected by partisan resistance during the Second World War as was Mather by the youthful sacrifices of the First, has suggested that this young man, the embodiment of republican virtue, is standing anxiously by moonlight before those bastions of the city walls that had been strengthened by Michelangelo against the forces of the emperor Charles v in 1529–30. The image changes dramatically if, as Janet Cox-Rearick proposed at the time the portrait was purchased by the Museum, it was painted in 1537 and depicts instead the swaggering confidence of young Cosimo de' Medici, newly installed as duke of the Florentine republic.

Various arguments in favor of identifying this young man as Cosimo i de' Medici were assembled by Cox-Rearick in the catalogue prepared for the sale of the picture in 1989. The J. Paul Getty Museum has since changed this identification in its own catalogue, tentatively agreeing with the proposals of Berti and others that the figure is Francesco Guardi.[14] Yet the debate continues, becoming even more heated in certain respects because the case for Francesco Guardi and against Cosimo has never been fully argued. Opinion has tended to change with the fashions of the times. In presenting the evidence for the identification of the sitter as Francesco Guardi, rather than Cosimo i

9

de' Medici, I will not be engaging in a detailed refutation of the claims put forward by the "Cosimo" camp. To do so would fill another book. But wherever possible the weaknesses and inconsistencies of these claims will be indicated in the notes. I will say at the outset, however, that the issue of likeness has proven to be the greatest stumbling block to acceptance of the Cosimo hypothesis, as put forward in 1989. In the sales catalogue Cox-Rearick admits that "it requires a leap of imagination to link the face in the Stillman [now Getty] portrait with [Bronzino's] later portraits of the duke."[15] She herself had earlier maintained that a complete lack of convincing likeness meant the portrait could not be of Cosimo.[16] Even after the discovery of the inventory Cox-Rearick had countenanced the identification only in connection with the suggestion that the portrait might represent Cosimo in the early 1530s, as a supporter of his cousin Duke Alessandro.[17] If the youth portrayed is about fifteen or sixteen (the same age proposed by supporters of the Guardi identification), it might just be possible, the argument goes, to explain away the lack of resemblance. In the sales catalogue, however, the date proposed is 1537, the resemblance is insisted upon, and the remainder of the argument relies on these claims. Cox-Rearick's case for "Cosimo," in which the hypotheses of various other scholars are combined, rests on six main considerations: provenance, likeness, style, costume, symbolic meaning, and influence. In the final analysis, only the question of provenance proves to be anything other than circular, and, as we shall see, even the evidence of the inventory is not beyond question.

It has been suggested that the Getty portrait does not represent an individual, but an ideally beautiful and sexually ambiguous youth, a bored dandy. According to one interpretation such an ideal image might have been used to inspire hero worship in boys. Today the sitters for many sixteenth-century Florentine portraits, such as Bronzino's *Portrait of a Young Man with a Book* [see FIGURE 51], to which the Getty picture is closely related, lack names. But there is no evidence that in the 1520s or 1530s any independent portrayal of a boy, youth, or man in Florence was undertaken as a celebration of ideal male beauty for its own sake, without any reference to identity. This is not to deny that such beauty was an asset, and that representations of it might become objects of desire. But Michelangelo's famous comment about his sculptures of Giuliano and Lorenzo de' Medici for the family chapel in San Lorenzo [see FIGURE 11]—that in a thousand years no one would care whether the dukes actually looked this way—was predicated on the fact that there could be no doubt, given their context, who these figures represented and what they stood for.

Figure 7
Pontormo. *Deposition*, 1525–28. Oil on panel, 313 × 192 cm (123¼ × 75⅝ in.). Florence, Capponi Chapel in the church of Santa Felicità. Photo: Canali Photobank, Italy.

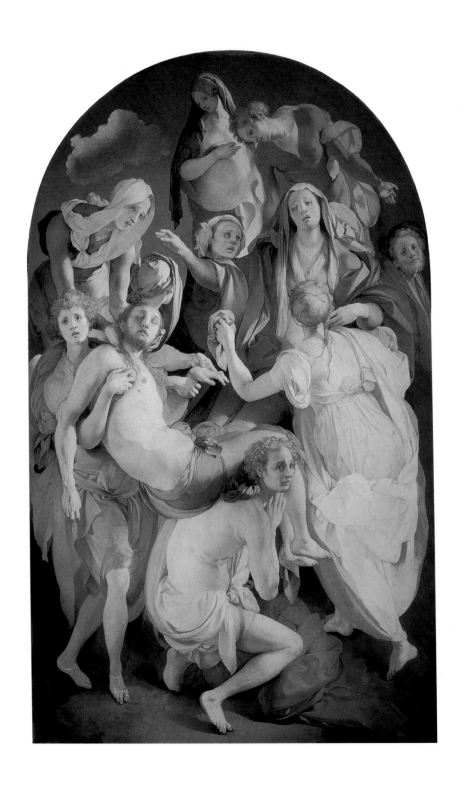

The cultural codes for the celebration of male beauty in Renaissance Italy are not so fixed that we can take for granted just what characteristics encouraged imitation or admiration. And we should not read modern notions of sexual ambiguity into the *Halberdier*'s expression without reference to the lively sixteenth-century discourse on beauty and gender. The very distinctions between boyhood, youth, and manhood have their own history in Renaissance Florence, and these may indeed help us to understand the portrait more profoundly.

Like families squabbling over old photographs, historians often disagree over the identification of portraits produced centuries ago. Such gaps in knowledge already existed during Pontormo's lifetime. When citing the artist's *Portrait of Two Men* (now in the Cini Foundation, Venice), for example, Vasari could not name the sitters.

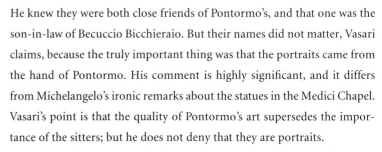

He knew they were both close friends of Pontormo's, and that one was the son-in-law of Becuccio Bicchieraio. But their names did not matter, Vasari claims, because the truly important thing was that the portraits came from the hand of Pontormo. His comment is highly significant, and it differs from Michelangelo's ironic remarks about the statues in the Medici Chapel. Vasari's point is that the quality of Pontormo's art supersedes the importance of the sitters; but he does not deny that they are portraits.

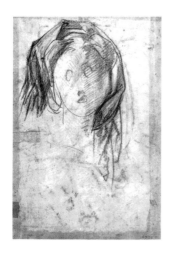

Figure 8
Pontormo. *Study for a Madonna*, circa 1518. Red chalk, 24.9 × 18.2 cm (9¾ × 7⅛ in.). Florence, Galleria degli Uffizi (6551Fv).

The longer we look at this extraordinary portrait, however, the more we see that nothing in it is entirely legible. There is a kind of minimalism at work: the pole weapon is not completely described; the architecture appears to be defensive, but we are shown only a corner; the costume seems military because of the finely wrought sword and the rough-hewn pole arm, but is otherwise splendid and immaculate. And, without conceding that this is not a portrait, even the luminous perfection of the face suggests metaphors like "the soft rosiness of youth," carried beyond individual identity. In Vasarian terms it even comes to stand for the perfection of youthful beauty as painted by Pontormo. Confirmation of this comes from the similarity of the youth's face to that of the young woman to the left in Pontormo's *Visitation* [see FIGURE 21], and to the faces of some of the figures in the *Deposition* for the Capponi Chapel [FIGURE 7]. Just how far Pontormo could go in abstracting this ideal may be illustrated by a study for a female head from around 1518 [FIGURE 8], and associable with the Madonna in Pontormo's altarpiece for the church of San Michele Visdomini. Some part of the content of the image must surely be an idea of beauty, shared with these figures. That

beauty is resplendent in a youth who stands for heroic virtue by means of his weapons, his assertively posed elbow, and his hat badge with its image of Hercules. But which youthful hero is this, and what does he defend?

Even in life the face of a beautiful adolescent bears few marks of experience, and much of the appeal of this portrait derives from the juxtaposition of exquisitely delicate flesh and fine clothing with the rough wooden pole of the weapon and the blankness of the green fortification wall. Is it possible that in the end, given Pontormo's accomplishment of such extraordinary contradictions, too much emphasis should not be placed on the fact that this doesn't "look like" Cosimo de' Medici? Almost too conveniently, contemporary sources come to our aid here. In the *Ragionamenti*, the imaginary dialogues in which he explains his frescoes in the Palazzo Vecchio to Cosimo's son,

Figure 9
Ridolfo Ghirlandaio
(Italian, 1483–1561).
*Portrait of Cosimo
de' Medici at Age Twelve*,
1531. Oil on panel,
86 × 66.5 cm (33 7/8 ×
26 1/8 in.). Florence,
Palazzo Medici-Riccardi.
Photo: Canali Photobank,
Italy.

Francesco, Vasari has the young prince look at portraits of his grandparents, Giovanni delle Bande Nere and Maria Salviati. Francesco then fails to recognize his own father in a portrait of him as he was six years before he became duke — that is, when Cosimo was twelve — which was based on one painted by Ridolfo Ghirlandaio in 1531 [FIGURE 9]. When Vasari tells him that this *giovanetto* is Cosimo, Francesco comments on it in the following way: "One recognizes his air a bit, but it doesn't call him to mind because I have seen very few portraits of him at that age; and the more so because His Excellency changed his appearance greatly every day."[18]

Was Vasari being witty about the way Cosimo had ultimately fixed his image so firmly that there was no mistaking it? Or was he perhaps accounting for the fact that he knew of portraits that were said to represent Cosimo, but did not resemble him very much, and which may indeed never have been portraits of Cosimo? One thing is certain: despite his admiration for Pontormo, Vasari chose Ghirlandaio's portrait, and not the *Halberdier*, as the model for his own frescoed image of the duke as a youth. Paired with this frescoed portrait of the twelve-year-old Cosimo was one of Cosimo's mother. Vasari based the latter on the very image of Maria Salviati by Pontormo recorded in the portrait now in Baltimore, which Keutner considered a pendant to the *Halberdier* on the basis of Vasari's account of the portraits painted in 1537. That Vasari chose Pontormo's portrait of Maria as his model, and yet did not choose the *Halberdier*, in theory its pendant, for his image of her youthful son, is very telling indeed.

A Portrait of Duke Cosimo
When He Was Young?

Portraits of unknown sitters were beginning to be collected in sixteenth-century Florence in the spirit of the view expressed by Vasari, that it was the hand of the artist that mattered more than anything else. Nonetheless, when the subject of a Florentine portrait remains anonymous today, this is most likely because its early history was lost as it passed out of the original family. So many families succeeded in keeping their collections together into the seventeenth century, however, that the number of unidentifiable portraits from this period is smaller than might be supposed. When family ties failed, it was often the Medici themselves who saved portraits from anonymity by collecting them. As they built their collection, the Medici placed export restrictions on the work of the greatest Florentine masters, including Pontormo's. In principle such restrictions did not apply to portraits, but the Medici collected these assiduously, especially if they were thought to represent friends or relatives.

What can the early history of the *Halberdier* tell us? The first documentary reference to the portrait, as we have seen, appears in the 1612 inventory of the Riccardi collection, made on the death of Riccardo Riccardi. Never married, Riccardo left an immense inheritance in trust to his two young nephews, a ten-year-old named Cosimo and his younger brother Gabriello. Among the properties entailed in this inheritance was the palace and estate known as Valfonda.

The Riccardi, originally from Pisa, had not always been prominent. However, by virtue of service to the Medici dukes and Florence, their status significantly changed. Riccardo was elected senator in 1596, and two years later, as an adornment to the family's new prestige, he purchased Valfonda. In 1600, after participating in the preliminary negotiations with the French crown, Riccardo hosted a lavish festival there to celebrate the marriage of Maria de' Medici and Henry IV of France. The Riccardi were raised to the aristocracy in 1606, and in an extraordinary transaction they would later buy the Palazzo Medici from their patrons in 1659.

Valfonda, now partly occupied by the railway station of Santa Maria Novella, was the largest piece of privately owned land within the walls of Florence [FIGURE 10]. The estate had been put together in the early sixteenth century by Giovanni

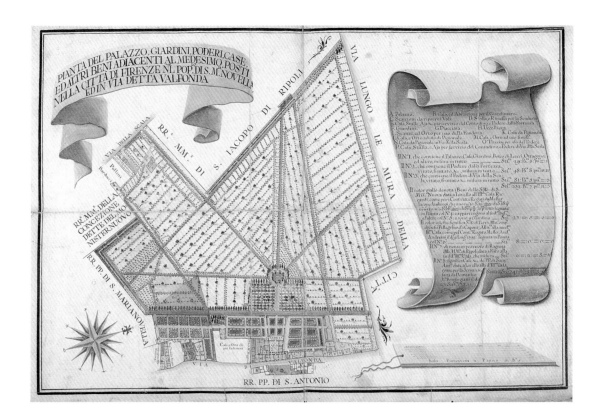

Figure 10
Plan of Valfonda. Archivio
di Stato, Florence,
Carte Riccardi 383,
no 1. Photo: Nicolò Orsi
Battaglini.

Bartolini, who embellished it with works of art, including a renowned sculpture of a *Young Bacchus* by Jacopo Sansovino. Yet Valfonda also remained a farm in the city, producing for the local market. In 1558 the Bartolini, forbidden to divide the property, were forced to sell it to Chiappino Vitelli.[19] In a letter to Bartolomeo Bartolini, sent from Poggio a Caiano on 14 August 1558, Cosimo I personally approved the sale. The Bartolini were closely allied with the Medici, and, according to Vasari, on his brother Giovanni's death Gherardo Bartolini gave the Sansovino *Bacchus* to Duke Cosimo. The new owner of Valfonda was an even more important Medici ally. Chiappino Vitelli helped secure Cosimo's power through military victory over the Sienese in 1558. Cosimo himself supported Chiappino's marriage to the widowed Leonora Cibò.

Each of Valfonda's owners improved the gardens and house, leaving some possessions behind. No known inventory before 1612, however, includes the paintings under discussion here, and a *Crucifix* by Sansovino (mentioned by Vasari together with other *cose antiche* and pieces by Michelangelo) remained in the possession of the Bartolini in 1568, some ten years after the sale of the house to Vitelli. It was almost certainly the Riccardi who accumulated the majority of the works recorded on Riccardo's death.

According to the 1612 inventory, much of Riccardo Riccardi's collection of ancient, medieval, and modern sculpture was in the courtyard, arranged around a fountain. The garden was watched over by a large statue of Boniface VIII and a figure of Aesculapius.[20] On entering the house the visitor was confronted by twenty-two Medici portraits, probably a version of the official collection propagated by Cosimo I; this was accompanied by a smaller group of portraits of famous men. The most important original works, including the Getty portrait, hung in a series of fifteen lunettes on the ground floor. The inventory is remarkable for the wealth of detail it provides on the sizes, subjects, and attributions of the paintings. Yet assignments of attribution and subject can change, and only an unbroken provenance can justify confident identification of any work.

Several paintings, however, can be identified from the details of the inventory, the most conspicuous of which is Pontormo's *Halberdier*. Given the crucial identification of the sitter as Duke Cosimo, the overall accuracy of the inventory is of immediate importance. Also vital is the question of what the inventory can tell us about the likelihood that Riccardo Riccardi owned a portrait by Pontormo of Cosimo I as a

youth. Even in summary the list of works hanging in the lunettes is remarkable. Of particular interest are the *Portrait of Maria Salviati with a Child*, already mentioned [see FIGURE 3]; a portrait attributed to Titian, which was probably the so-called *Sultana Rossa* (no longer given to Titian, and now in the Ringling Museum of Art, Sarasota); a portrait of a man attributed to Raphael (now given to Tommaso di Stefano, and in the Carnegie Museum of Art, Pittsburgh); a portrait of a man by Rosso Fiorentino (possibly the one in the National Gallery of Art in Washington); the *Portrait of a Woman with a Dog* (now in Frankfurt and generally attributed to Bronzino, but cited as a Pontormo in the inventory); a portrait by Bronzino of Grand Duke Cosimo as an old man, which must have been a version of the last state portrait invented by Bronzino, toward 1570; portraits of Grand Duke Ferdinand (Cosimo's son) and his duchess. A second portrait also attributed to Pontormo, and also said to be of Duke Cosimo, has been identified with a work now belonging to the Barbara Piasecka Johnson Collection Foundation [see FIGURE 52]. Among the many works in other rooms were religious subjects by Andrea del Sarto, Puligo, and Fra Bartolommeo, as well as a Medici and Lorraine coat of arms. A horizontal canvas by Pontormo in chiaroscuro must be the so-called *Joseph and Rebecca Deceiving Isaac* now in the Uffizi, a later work that was almost certainly part of a festival decoration for the Medici. Two more chiaroscuros of histories or fables were given confidently to Francesco Granacci. These were probably from the triumphal arch erected for the entry of the first Medici pope, Leo x, into Florence in 1515, and which Vasari describes as filled with *storie* and *fantasie* in chiaroscuro. The inventory also lists a portrait of Giovanni delle Bande Nere (Cosimo's father), by Titian. This would have been a copy of the portrait now in the Uffizi; the Uffizi portrait was actually painted by Gian Paolo Pace, but Aretino sent it to Cosimo i in Florence in 1545 as a Titian. In the large room upstairs were more paintings in chiaroscuro, which must be connected with canvases now in the Uffizi (of which three are generally given to Sarto or his shop and the fourth to Pontormo), and with two smaller ones in Rome; all have been associated with Medici festival decorations.[21] In addition were works attributed to Giovanni Antonio Sogliani, Cecchino Salviati, and Ridolfo Ghirlandaio, among others. In Riccardo's study was a collection of busts, and several important ancient, early Christian, and medieval ivories.

Riccardo Riccardi had been a member of the Accademia del Disegno, the academy of art founded by Cosimo i. According to Giorgio Vasari the Younger, he

refused the office of consul just before his death, and died in debt to the institution.[22] Riccardo's interests are reflected in the fact that Valfonda became a haven for artists, and his heirs continued this tradition. A sort of extension of the Accademia del Disegno, Valfonda was not just a large private house with a garden. It was a place where artists could study the collection and where a lucky few could find lodging and studio space.[23] Comparable in character, if not in the extent of its collections, to the great Roman gardens of the Borghese and the Giustiniani, Valfonda was a public place. It was described by Cinelli in his guidebook of 1591 as one of the most important casinos in Florence: like the casino at San Marco, it existed for the delight of lovers of art.

By 1612 Cosimo I had been dead for only thirty-eight years. If the Getty portrait does not represent him, could the youthful *Halberdier's* identification as the duke as a young man in the inventory have been wholly invented and passed off as such? Whoever drew up the inventory was also close to the Accademia. Like the inspectors responsible for enforcing export legislation, he was well informed about Florentine masters, being able to recognize not only a Pontormo, a Sarto, and a Rosso, but also a Granacci, a Ridolfo Ghirlandaio, a Sogliani, and a Puligo. Moreover, the collection itself was extraordinarily rich in works by artists of Pontormo's generation. Although Berti has insisted that a portrait of Cosimo I by Pontormo could never have escaped the Medici collection, he did not ask how five other Pontormos could also have escaped; the paintings in chiaroscuro, all probably produced for Medici festivals, make this question even more pressing.

When the pageant celebrating the marriage of Maria de' Medici to the king of France was staged at Valfonda on 8 October 1600, the presence of Medici family imagery would have been striking. The tradition of hanging ancestral portraits at Medici weddings goes back to the marriage of Lorenzo the Magnificent and Clarice Orsini in 1469. At the marriages of Lorenzo, duke of Urbino, in 1518, and of Duke Alessandro in 1536, the practice was repeated, as it was for the wedding of Cosimo I in 1539. All these festivities took place in the courtyard of the Palazzo Medici. When Ferdinando I decided to allow Riccardo Riccardi to provide entertainment for the wedding in 1600, the Riccardi had every reason to imitate their patrons. If indeed the paintings described in the inventory were hanging in the casino at the time of the wedding, and identified as they would be twelve years later, then the wedding guests would have been introduced to portraits said to represent Maria de' Medici's great-grandmother Maria

Salviati [see FIGURE 3], her great-grandfather Giovanni delle Bande Nere, her grand-father Cosimo I as a young man [see FIGURES 1, 52], and also as an older man, as well as Maria's uncle Ferdinando I and his wife, Cristina of Lorraine, whose joint coat of arms appeared over the door.

Yet if the *Halberdier* is an original portrait of Cosimo de' Medici, why was it not in the Medici collection in 1612? For Berti the only possible solution is that the Riccardi bought Pontormo's portrait of Francesco Guardi (whom Berti assumes was a Medici opponent) for their collection and then changed its compromising republican identity for one more in keeping with their support for the grand duke. But even if, on account of the sitter's youth, no one in the Riccardis' circle challenged such a reidentifi-cation, this does not explain why the Guardi portrait—if such it is—was available for purchase, or why it was not, like so many others, snapped up by the Medicis themselves as a work from the hand of Pontormo.

Philippe Costamagna has speculated that four of the portraits listed in the inventory—the Getty portrait, the two now in Frankfurt and Baltimore, and the one that he associates with the Piasecka Johnson portrait—all represent members of the Medici family, and that they all came from the collection of Ottaviano de' Medici.[24] Ottaviano was dedicated to building a set of such family portraits, and he employed Pontormo in this connection on several occasions. One of Ottaviano's heirs, the argu-ment goes, may have sold the collection on leaving Florence. Yet it is hard to imagine why any of his heirs would not rather have sold such an important group of original Medici portraits by a favored artist to his own Medici relatives. In 1568, for example, Vasari described Pontormo's posthumous portrait of Cosimo il Vecchio as being in the house of Ottaviano, and in the possession of Ottaviano's son Alessandro. By 1587 this portrait was in the grand-ducal collection. The Getty *Halberdier* was not. It is strik-ing, moreover, that Vasari never mentioned a portrait of Duke Cosimo by Pontormo in Ottaviano's possession, since he missed few chances to refer to important works in his friend's collection. We have already noted that Vasari used the Valfonda portrait of Maria Salviati as the basis for his portrayal of her in the Palazzo Vecchio, and that he did not use the Valfonda *Halberdier* as his model for Cosimo.

There exists a slight possibility that some of these portraits might have come to Valfonda through Chiappino Vitelli, the general who secured Siena for Cosimo, and from whose grandson the Riccardi purchased the property in 1598. When

Chiappino's uncle, Alessandro Vitelli, seized the Fortezza da Basso after the assassination of Alessandro de' Medici in 1537, he took with him not only Alessandro's widow, but also many treasures from the Palazzo Medici and the old house in the Via Larga where Cosimo lived. Chiappino could also have acquired some pictures through his wife, Leonora Malaspina Cibò. She was, after all, the daughter of Ricciarda Malaspina, whose residence in the Palazzo Pazzi had been Alessandro de' Medici's favorite haunt. It was to Ricciarda's sister Taddea that Alessandro de' Medici gave *his* Pontormo portrait [see FIGURE 6]. That Cosimo I went to such great lengths to recover the latter makes it very doubtful, however, that a portrait of Cosimo himself by Pontormo could have remained in Vitelli's hands to be passed on to the Riccardi. Before 1612 the silence over the *Halberdier* as a Medici portrait is deafening.

In response to the question of how the Riccardi could have gotten away with a false claim that this was a youthful portrait of Cosimo, one point should be made. This concerns motive. Rather than assuming that they wanted to enhance the status of this portrait for social advantage, we should consider that the Riccardi may have believed in the identification. Genuine confusions of identity occurred even in the Medici's own collection: in the 1635 inventory of the Tribuna in the Uffizi, for example, Pontormo's *Portrait of a Young Man* (now in Lucca) was described as a portrait of Giuliano de' Medici, an identification no longer generally accepted. In each case the portrait was said to be of a Medici sitter when he was young, and so, presumably, less easily recognizable. One reason for the identification in the case of the Getty portrait may lie in the image of Hercules and Antaeus on the hat badge, to which modern historians also point as evidence. The young duke adopted this image as a personal emblem, and it is easy to see why a young man wearing it in his hat might be assumed to be Cosimo. Nor should the closeness of Riccardo Riccardi to the Accademia del Disegno be forgotten. Riccardo would have read his Vasari, and like modern art historians he would have known the passage cited by Keutner in which Vasari reports that, when commissioned to paint at Castello, Pontormo painted portraits of both Cosimo and his mother. Riccardo owned a portrait of Maria Salviati by Pontormo (though how did he acquire this?). Why not, then, identify this young man as Cosimo, for whom Riccardo's heir had been named, and whose dynasty he had served so well?

If this is the case, then Riccardo Riccardi, like many modern scholars, was probably misreading Vasari, who writes regarding the painting of the loggia at Castello

that Pontormo "receiv[ed] for this eight scudi a month from His Excellency; whom he portrayed, young as he then was at the beginning of that work, and likewise Signora Donna Maria his mother."[25]

Instead of taking this to mean that Pontormo painted two independent works, it seems just as likely that Pontormo painted portraits of Cosimo and Maria *at the beginning of that work*, including them, that is, in the frescoed lunettes.[26] Since the frescoes were soon consumed by the elements (their disintegration was already noted by Vasari), this must remain a hypothesis. If there were independent portraits, Vasari makes no further mention of them, even in reference to the collections of the Medici.

The Riccardi inventory records the collection of a wealthy and important man in fascinating detail. However, despite the distinguished Medicean company in which the Getty *Halberdier* found itself in 1612, the identification of the sitter as Cosimo I remains questionable. Before the discovery of the inventory no one proposed it. Without the inventory the identification of the *Halberdier* as Cosimo I would most likely never have been put forward.

A Portrait of Francesco Guardi?

I t was Vasari who identified Francesco Guardi as one of Pontormo's sitters, and so in the course of this book I propose to follow his description in detail, taking into consideration other arguments as I go.

"At the time of the siege of Florence . . ."

Vasari reports that Guardi's portrait was painted "at the time of the siege." What was the siege of Florence, and how might understanding this historical moment help to define our portrait?

If the siege had a definite beginning it was late in October 1529, when Malatesta Baglione, commander of the troops of the Florentine republic, led all the musicians in Florence to the defense works newly thrown-up at San Miniato al Monte. After they had played, a herald delivered a formal challenge to the prince of Orange. Commander of all the mercenary troops in the service of Emperor Charles v, the prince was installed outside the walls at the Villa Guicciardini in the Pian de' Giullari [see FIG-URE 14]. Upon the herald's return, the musicians struck up once again. Their chorus was followed by the firing of every piece of cannon within the city walls for a full hour. In response, on 29 October, the campanile of San Miniato was hit by no fewer than fifty cannonballs from the enemy side.[27]

The siege would not be lifted until 12 August 1530, when the last Florentine republic surrendered to the emperor. At that moment Florence became an imperial feudality, soon to be placed under the rule of the Medici, whom Charles v created its first dukes. The city, whose wartime population of about 110,000 had held out against the powers of pope and emperor for ten bitter months, was never to reclaim its republican liberty. Between the ritual of the opening shots and the ignominy of the final days of the siege some 36,000 Florentines—or fully one third of the city's population—died. After the population stabilized at the end of the war and soldiers and refugees had left, only some 54,000 souls remained. Altogether Florence had lost one half of her population in

the decade of the 1520s; under the republic the plague had already claimed 30,000 lives in 1527–28 alone, and the war was a crippling blow to an unprepared and vastly outnumbered people. From this devastation the city would never recover.[28]

Politically, the siege did not come to an end until July 1531, when Alessandro de' Medici (thought to be the illegitimate son of Lorenzo de' Medici, duke of Urbino; but probably fathered by Giulio de' Medici, who was now Pope Clement VII) made his triumphal entry into the city under the protection of Emperor Charles V. The elected government, or Signoria, was abolished in 1532, and Florence was given by notarial deed to Alessandro as duke of the Florentine republic. When the arrogant and profligate Alessandro was murdered by his cousin Lorenzo (called "Lorenzaccio") on the eve of the feast of the Magi in 1537, a group of citizens gathered to discuss a return to more popular government. They were brusquely informed by the imperial commander, Alessandro Vitelli, that they must choose a new duke or he would cut them to pieces on the spot. Their choice was the young Cosimo de' Medici, son of Giovanni delle Bande Nere.

The siege witnessed many acts of courage, accounting for the great interest in these events at the time of the *Risorgimento* and unification of Italy in the nineteenth century, an interest that has also influenced romantic interpretation of the Getty portrait. The most desperate act of heroism was the decision by the Florentines on 15 June 1530 that all the armed forces, both the mercenaries and the local citizen militias, would make a final sortie out of the city to engage the enemy. Should a rout ensue, it was determined that those who remained to guard the gates were to slay all the women and children and set fire to Florence "so that with the destruction of the city there shall not remain anything but the memory of the greatness of the soul of its people."[29] Baglione, commander-in-chief of the Florentine army, and Stefano Colonna, supreme commander of the citizen militia, both refused to allow this reenactment of the self-destruction of the ancient city of Saguntum to happen. The city was not to be allowed to fulfill its cry of "Florence in ashes rather than the Medici."[30] Baglione had probably been in secret negotiations with Pope Clement VII all along, conspiring to bring Florence to her knees from within through the expenditure of men and money. He was not to engage in actions that would lead to the destruction of the most beautiful city in Europe, which Clement considered a family possession. Baglione finally persuaded an influential group of young men—two or three hundred members of the militia—to join him in Piazza Santo Spirito on the eve of the feast of San Lorenzo. There they declared their allegiance to the Medici.

To attempt to understand how Florence came to be subjected to the deceptions of international diplomacy, the brutality of foreign invasion, the bitterness of civil war, and to the threat of destruction by violent, undisciplined troops who were often as hungry and desperate as those they oppressed, is to understand the history of Europe in the first thirty years of the sixteenth century—not to mention the history of Florence from the time of the return of the Medici as de facto rulers in 1434. Everything, from the broadest geopolitical forces to the narrowest selfish interests, would seem to have conspired to bring about the crisis of 1529–30.

After 1494, when Charles VIII of France had demonstrated with the power of his artillery how easy it was to march through the peninsula, Italy became the theater for protracted wars of foreign domination, a glittering prize fought over primarily by France and Spain. The coronation of Charles V as Holy Roman Emperor in Germany in 1520 made war over Italy almost inevitable. Charles, threatened by religious reform in the north, and facing economic and political chaos throughout his empire, sought to control the territory between Germany and Naples, and to dominate the papacy. Florence was to play a key role in that war, and the reasons for this were simple. In August 1529, the Spanish ambassador in Rome summed them up for Charles V: "Florence is of much importance," he wrote, "both for its situation and for the money which it can, and did, contribute in time of war; and therefore it seems necessary not only to detach it from the enemy but also to win it over to the devotion of your Majesty." [31]

The enemy to which the ambassador referred was France, and Florence's determination to keep to its French alliance was one of the factors that led to the events of 1529–30. Defeated at the Battle of Pavia in 1525, the French king, Francis I, was forced to sign a treaty abandoning his claims to Italy. After the sack of Rome in 1527 he returned to besiege Naples, but there, on the eve of victory, plague destroyed his army. This time, in August 1529, Francis was forced to agree to the shameful Peace of Cambrai, renouncing all claims to Italy and paying a huge sum to the king of Spain. More importantly he left his two sons as hostages to the peace. The king's mother is reported to have said that he would have sacrificed a thousand Florentines to get his children back. He would certainly do nothing for Florence that would put his sons in jeopardy.

Between the death of Lorenzo the Magnificent in 1492 and the assumption of power by Duke Alessandro in 1531–32, Florence could enjoy peace only if others permitted. The Medici were expelled in 1494, and when Piero Soderini became gonfaloniere (chief of the priors and effective head of state) for life in 1502, he was able to govern the

republic because the struggles by various foreign powers for control of Italy were temporarily exhausted. But when Pope Julius II created the Holy League together with Venice and Spain in order to drive the French out of the peninsula, it was only a matter of time before Florence would suffer for her historical alliance with France. In 1512, after Spanish troops had sacked neighboring Prato, Florence had to agree to the return of the Medici. Cardinal Giovanni, son of Lorenzo the Magnificent, reclaimed the family palace and forced a return to a Medicean form of government, in which a small group of loyalists manipulated the elective bodies. Then, in another turn of fate, Giovanni was elected pope as Leo X on the death of Julius II in 1513. Having secured Florence, Leo determined to expand and enhance his family power. He set about arranging noble marriages that would give his heirs international and hereditary aristocratic standing. The king of France was persuaded to give Giuliano, Leo's younger brother, the title of duke of Nemours, and to provide him with a noble wife. In 1516 Leo X declared his nephew, Lorenzo di Piero, duke of Urbino, and in 1518 married him to Madeleine de La Tour d'Auvergne. Although Catherine de' Medici, the future queen of France, would issue from this last union, neither marriage fulfilled Leo's ambitions, for Giuliano died in 1516 and Lorenzo in 1519, and with them ended the male descent of Cosimo il Vecchio and Lorenzo the Magnificent. These were the frustrated dynastic hopes that Michelangelo was to commemorate in the Medici Chapel in San Lorenzo in the 1520s [FIGURE 11].

Not only premature deaths, however, defeated Leo's ambitions. The newly elected Charles V had determined to go to war with France to gain control over Italy, and the pope recklessly cast his lot with him in the hope of territorial gain. Only after Leo's death, and the defeat of Francis I at Pavia in 1525, did the full horror of leaving Italy in the power of the emperor become clear. It was the fate of another Medici pope to suffer the catastrophic results. Clement VII was unable to put together an alliance against Charles, who had come to see the capture of the pope as the solution to many of his problems. Though Florence was spared as the imperial armies marched south through Italy, Rome was not so lucky. When they reached Rome on 6 May 1527, the unfed and unpaid mercenaries sacked and ravaged the city for eight days. The pope barely escaped to Castel Sant'Angelo, where he remained a prisoner at the bidding of the emperor.

When he freed the pope in December 1527, Charles saw how much he had to gain from his support. Religious reformers in northern Europe were as often opposed to the empire as they were to Rome, and he needed Clement's help to deal with the royal

Figure 11
Michelangelo Buonarroti (Italian, 1475–1564). *Tomb of Giuliano de' Medici*, circa 1519–34. Marble and *pietra serena*, H: 600 cm (236¼ in.). Florence, Medici Chapel in the church of San Lorenzo. Photo: Canali Photobank, Italy.

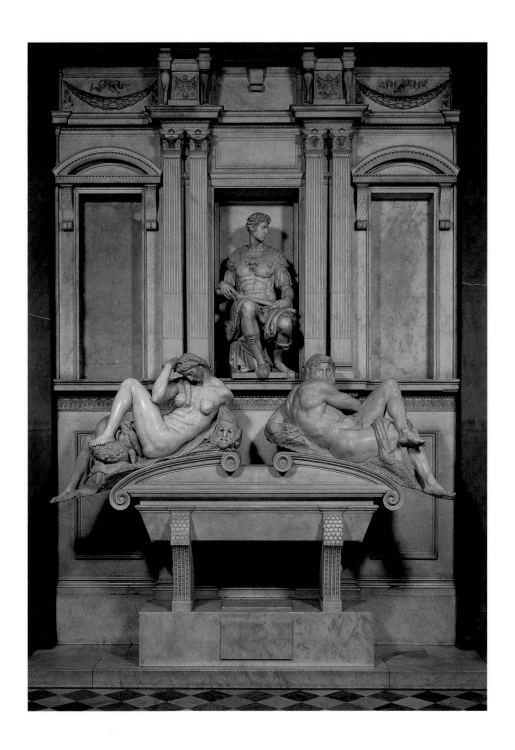

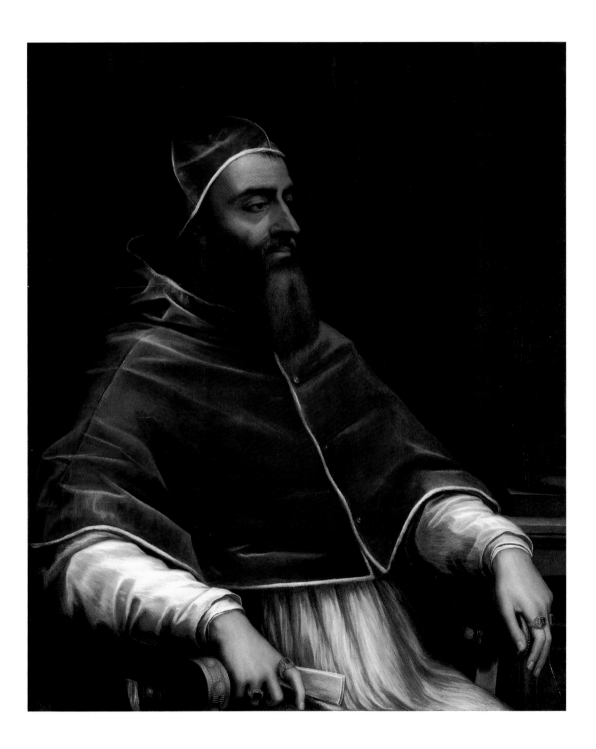

divorce in England. He also needed Clement's money, which was to say he needed the riches of Florence. If the price for Charles's coronation by the pope, and for the filling of his coffers, was the delivery of Florence to his new ally, Florentines would be powerless to stop the course of events. When the emperor and the pope celebrated their peace, the fate of Florence was sealed. Had it not been for Clement, Charles v might have been bought off by Florentine gold. Had the fractious Florentines been able to reach political solutions more quickly, the last republic might even have abandoned the French alliance and made peace with the emperor in time. Had it not been for their hatred of the Medici, some Florentines might have agreed to their return without a war. And had it not been for Clement's personal fury at Florence, he might have been less vindictive in the persecution of his enemies. But, as he told the English envoys in 1529, he would rather serve in the emperor's stable than endure the insults of his subjects and vassals: he was not God, but man, and would use every means, whether force or fraud, to defend his own and recover what he had lost.[32]

Many Florentines, grown rich from papal banking, had supported the ambitions of Leo x, and they had prospered under the local rule of Cardinal Giulio de' Medici. Giulio's election to the papacy as Clement vii [FIGURE 12], however, provoked a crisis. As the contemporary historian Vettori saw it, Giulio was transformed from "a great and renowned cardinal into a small and little esteemed pope."[33] Huge sums of money were sent to finance papal policies, and the pope ran the city as a personal fiefdom, as if he were its prince. By 1526 all the extraordinary income of the commune was being requisitioned to pay for the war of the Holy League.[34]

The rising military and financial crises were compounded by political and personal ones. In 1524, after Cardinal Giulio departed for Rome, he sent Silvio Passerini, cardinal of Cortona, to Florence as his unofficial deputy. Passerini was soon joined by the two illegitimate boys, Ippolito and Alessandro de' Medici, who were Clement's hopes for the future of the dynasty. More important than the actual parentage of these children was the fact that their protector, Passerini, was held in total contempt by the citizenry. He, in return, showed no regard for political compromise, excluding from government all who were not outright Medici courtiers.

Although there were some in Florence, such as Roberto Pucci and Ottaviano de' Medici, who would indeed follow the Medici in any circumstances, there were many other citizens—such wealthy and powerful men as Filippo Strozzi, Jacopo Salviati, and

Niccolò Capponi—who had supported the Medici regime, but who would never agree to their holding princely court. With the continuing attacks from the Savonarola-inspired popular movement, and with the threat to peace from the pope's disastrous foreign policies added to this discontent, it was only a matter of time before Clement VII's ambitions would be challenged. News of the death of Giovanni delle Bande Nere at the hands of landsknechts in 1526, and now the proximity of imperial troops marching to Rome, further fueled the unrest.

On Friday, 26 April 1527, amidst shortages of food and panic about the approaching imperial army, and while Passerini and the Medici pretenders were out of town, a market brawl exploded into an invasion of the Palazzo della Signoria. A band of youths demanded arms and a return to the constitution of 1512.[35] Passerini succeeded in slipping back into Florence after what came to be known as the *Tumulto del venerdì*, but it was evident that he could count on no one. The final catalyst was the news from Rome of the sack. Passerini agreed to take his unpopular charges away for good as forces within the city struggled for control. The constitution essentially returned to that of the anti-Medicean republic of 1494.

Despite the efforts of more conservative leaders to prevent it, this new republic vented its hatred of the Medici, sequestering and selling their property. Prominent Medicean supporters, who were contemptuously known as *Palleschi* (ballers, from the balls on the Medici coat of arms), were imprisoned or banished. Tensions between those wealthy and powerful *Ottimati* (Optimates) who had favored the Medici (but only as citizen-rulers of Florence) and the increasingly bold, reformist, and often Savonarola-inspired youth became harder to ignore. The election of Niccolò Capponi as gonfaloniere on 31 May 1527 secured moderation for a while; but Capponi was opposed from the very beginning by enemies of the Medici and of anyone who had ever supported them. And so, despite Capponi, and despite the efforts of many other moderates, the power of the anti-Mediceans grew. No longer satisfied with harangues against Clement VII and with threats to raze the Palazzo Medici, the Consiglio Maggiore sought again to legislate the religious zealotry that had been preached by Savonarola. In 1528, in a unification of religious and political ideology, it was declared that Jesus Christ was the "sole and true lord and king" of the republic, and a crown of thorns was placed over the door of the Palazzo della Signoria.

Niccolò Capponi came to believe that peace with Clement was the only solution. Caught negotiating with the pope, he lost his position as gonfaloniere in April

1529 to the anti-Medicean radical Francesco Carducci. Capponi would die on the very eve of the siege in October 1529.

Francesco Carducci's older brother Baldassare had led the *Arrabbiati* (the Outraged, who were allied to the followers of Savonarola and the most radical agitators for more democratic political change) and had once been imprisoned in Venice for calling Clement VII a *bastardazzio*. Such personal attacks on the pope proliferated. There were even demands that the epitaph on the grave of the pope's revered ancestor, Cosimo il Vecchio, naming him *Pater Patriae*, be removed. The Medici, this petitioner argued,

> deserve to be burnt in their palace and given to the dogs. Those who do not want this vote to succeed wish to have a foot in both camps: they want to protect themselves against the future, and they await the return of these tyrants.[36]

Such attacks on the pope's character and ancestry by the notoriously critical Florentines, who called him not "Papa Clemente" but *Papa chi mente* (pope who lies) enraged Clement as much as the destruction and seizure of his property. He wanted Florence back at all costs and promised to pay the emperor handsomely out of Florence's riches for delivering it.

Almost every moment in the siege of Florence is documented. Local government recorded its deliberations; and diplomats were in regular correspondence with their courts, whether written openly in Italian or in invisible ink or cypher. The new forms of political history writing pioneered by Machiavelli and Guicciardini were adopted by such writers as Bernardo Segni, Filippo de' Nerli, Jacopo Nardi, and by Pontormo's and Vasari's friend Benedetto Varchi, all of whom wrote accounts of the siege. Yet nowhere in these records—in which appear the names of military and political leaders from the topmost command to the captains of the militia, of local heroes who manned cannons or ran hospitals, of those who had their property confiscated, or even of traitors who ran away or passed secrets—has any reference to either Jacopo Pontormo or Francesco Guardi as actual participants in the conduct of the siege been found.

If the *Halberdier* is not a portrait of Cosimo, but rather the portrait of Francesco Guardi described by Vasari, then the young man's lack of even modest historical fame makes it all the more difficult to be sure where the subject of the Getty picture stands, literally or figuratively, or under what circumstances Pontormo painted his portrait. What *is* the structure behind this young man, and what side of the circle of walls so

31

Figure 13
Andrea del Sarto (Italian, 1486–1530). *Porta a Pinti Madonna (Madonna and Child with the Infant Saint John)*, circa 1522. Copy by unknown artist. Oil on wood, 55.3 × 39 cm (21¾ × 15⅜ in.). Birmingham (U.K.), The Barber Institute of Fine Arts, The University of Birmingham (46.1).

tightly closed around Florence at the time of the siege was he on? Pontormo's position is also of interest. On which side did *he* stand during the siege, and where and why might he have been commissioned to paint this young man? Without answers to these questions we cannot begin to know what this youth *stands for*.

THE SIEGE: WALLS · The young man in our portrait stands before some kind of fortification. The projecting angle of the wall reveals Pontormo's fascination with a similar, highly original, space-creating device favored by his teacher Andrea del Sarto. It is exemplified best in Sarto's design of circa 1522 for a tabernacle just outside the Porta a Pinti, which is known only in several copies [FIGURE 13]. Appropriate for its site outside

a city gate, Sarto's invention establishes that for contemporary viewers such an angle carried the meaning of "outside the walls." Pontormo's use of this device is even more abstract, but the bare green surface and angled articulation at the level of the sitter's hat and wrist concisely convey the notion that this is a corner fortified against attack.

THE SIEGE: OUTSIDE THE WALLS · The situation outside the city walls in 1529–30 is most vividly described in Vasari's fresco of the siege [FIGURE 14] in the Sala di Clemente VII in the Palazzo Vecchio. Painted some thirty years after the events, and designed by a Medicean artist who did not witness them, it nevertheless remains an historical document of great value. Vasari himself describes the difficulty he faced in creating such a document, and how he had to climb to the highest point possible in the hills of Arcetri overlooking Florence to draw his panoramic view from the roof of a house. Into the carefully delineated terrain, which he coordinated with the help of a schematic plan of the city, he fitted encampments of soldiers and numerous incidents of the siege based on eyewitness accounts and documents. For all his research, however, Vasari's version of the events is subtly partisan.

To record a similar military engagement for his woodcut *The Encampment of Charles V at Ingolstadt* (published in 1549), the German artist Hans Mielich also climbed high. At the lower edge of the composition he portrayed himself drawing the

Figure 14
Giorgio Vasari (Italian, 1511–1574). *The Siege of Florence*, 1561. Fresco. Florence, Sala di Clemente VII, Palazzo Vecchio. Photo: Canali Photobank, Italy.

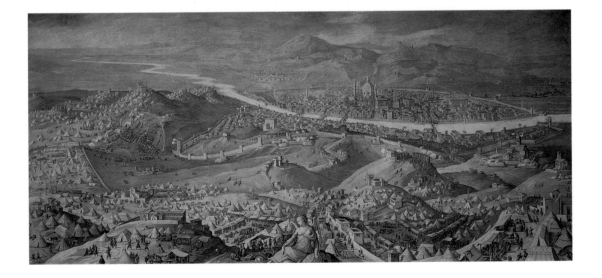

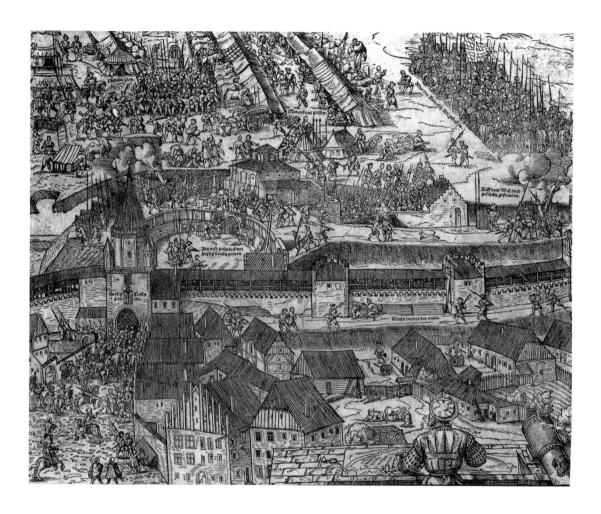

Figure 15
Hans Mielich (German 1515–1573). *The Encampment of Charles V at Ingolstadt* (detail), 1549. Woodcut in sixteen pieces. Nuremberg, Germanisches National-museum (HB 270 and HB 10724).

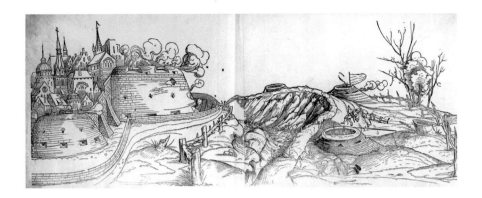

scene from the very top of the Frauenkirche [FIGURE 15]. From this viewpoint within the city he could see a few citizens, mounted soldiers massed at the gate, and a number of halberdiers, identified as the "watch behind the wall." Mielich's principal interest, however, was in showing the overwhelming numbers of hostile imperial troops and their deployment in a temporary city outside these walls. In 1561 Vasari quite deliberately identifies instead with the besieging victors, and shows an almost deserted city across the river from the densely populated, hilly landscape.

Ignoring the fact that the imperial troops were constantly on the verge of rebellion, Vasari underlines the orderliness of life in the besieging army. The armed camps are dotted with gallows, suggesting that justice was swiftly dispatched; markets and kitchens bustle with activity; and flags fly from all the buildings in the countryside. In this well-governed world of tents we are shown the commissary at Arcetri, where the German troops were established, with the Spanish and the Italians billeted to either side of them. The prince of Orange, viceroy of Naples and commander of the imperial army in Italy, is shown in his quarters in the Villa Guicciardini, visible near the Pian de' Giullari. Pier Maria de' Rossi, count of San Secondo and the nephew of Giovanni delle Bande Nere, appears placed with all of his firepower at the Torre del Gallo. Most threatening, and also clearly delineated by Vasari, was Alessandro Vitelli's occupation of the villa at Giramonte and of the Piazzuola degli Unganelli. From this high ground he could pound the defenses of the republic at San Miniato.

Of military action in the fresco there is little. Although the practice of building advanced sconces—so prominently shown in Erhard Schön's 1535 print of the *Siege of Münster* [FIGURE 16]—was in decline, such sconces had indeed been built by the imperial army as it advanced its earthworks toward Florence. However, Vasari instead

Figure 16
Erhard Schön (German, circa 1491–circa 1542). *The Siege of Münster* (detail), 1535. Woodcut. London, Warburg Institute, University of London (Bartsch nos. 248 and 249). © Warburg Institute.

shows a no-man's-land between the walls and the armies, which suggests little close combat. Yet we cannot fail to see that Vitelli's cannons are in full fire from Giramonte toward San Miniato, from which fire is returned [FIGURE 17]. Near San Salvi an army marches across the green plain. That green plain around Florence will be part of our story.

Figure 17
The Siege of Florence
(detail of figure 14),
showing the cannon
at Giramonte firing on
San Miniato. Photo:
Canali Photobank, Italy.

THE SIEGE: FORTIFICATIONS · Florence had never been sacked and had never endured cannon warfare. Even after the effectiveness of artillery fire had been fully impressed on Italy by the invasion of Charles VIII in 1494, Florentine confidence in the inadequate fourteenth-century walls persisted. There was also a prevailing conviction that the hills around the city were her most effective defense. A large army could not survive a siege within them, and a small army could not take the city. However, the truce between Francis I and Charles V in 1525 had awakened Clement VII to the impending danger of invasion facing both Florence and Rome, and the perils presented by the new forms of warfare. After commissioning a report on Florence's defenses from Niccolò Machiavelli, he put the architect Antonio da Sangallo the Younger in charge of mod-

ernizing the city's fortifications. Machiavelli's plan had been to redraw the eastern defensive line to the river, essentially cutting off the hills of San Miniato and Giramonte and destroying the *borgo* of San Niccolò. Sangallo instead acceded to the pope's desire to defend San Miniato and began constructing a series of modern angle-bastions between San Miniato and Giramonte, coordinating them with another bastion built at the Porta San Giorgio to the west. He pulled down the medieval towers at the various gates, seeing how vulnerable these were to artillery. On the expulsion of the Medici in 1527, Sangallo would turn to designing the imperialist attack.

At this point the new government of the city sought advice from Michelangelo, and the defense of San Miniato and Giramonte immediately became an issue. Michelangelo wanted to consolidate the defense works, and he persuaded the authorities to tear down the bastions toward Giramonte. The defense of the high ground of San Miniato remained crucial, however, and in this he found himself at odds with Niccolò Capponi. It cannot be proved that the gonfaloniere was opposed to any steps that would prolong the inevitable conflict, but Michelangelo, unwavering in the defense of San Miniato against Giramonte, became so suspicious of this that he dared not leave the site lest his efforts be sabotaged.

In 1529, with the situation clearly worsening, Michelangelo was put in charge of constructing all the defenses of Florence. He saw to it that the walls were repaired, and he strengthened the gates, which were to be fronted with earthworks [FIGURE 18]. Earth was piled up everywhere as ditches were dug and walls secured. But it was at San

Figure 18
Michelangelo Buonarroti. *Design for the Fortifications of Florence*, circa 1528–29. Red and black chalk with pen and wash, 20.4 × 27.4 cm (8 × 10¾ in.). Florence, Casa Buonarroti (28Ar). Photo: Canali Photobank, Italy.

Miniato that Michelangelo staked his all, being determined to create an impenetrable barrier there as quickly as possible. Peasants from the country and workers over the age of fourteen from the city were drafted to work day and night for rations of bread and wine. Instead of the clods of earth usually employed for such defenses, Michelangelo contrived to build the walls of unbaked earthen brick, constructed on a wooden armature and held together with manure and hemp.

In the midst of all this, on 21 September 1529, one month before the enemy surrounded the city, Michelangelo fled. Much has been made of his loss of nerve as a failure of patriotism—he planned, it seems, to place himself under the protection of the king of France. However, given Capponi's apparent opposition to his determination to prepare Florence for a prolonged defense, and the very real possibility that terms were already being negotiated with Malatesta Baglione, Michelangelo's own story that he had been warned that a secret peace was being made with the pope for the return of the Medici rings true. He had, after all, left his commission as architect and sculptor of the Medici Chapel in San Lorenzo to apply his full talent and knowledge in the defense of Florence against his patrons.

Michelangelo returned to Florence in November and was both punished and forgiven. But in the meantime drastic measures had been taken. Following Machiavelli's theory that a city should be protected by at least one mile of cleared land, offering no support of any kind to the enemy, the Consiglio di Ottanta (Council of Eighty) had determined in July that all buildings within a mile of the walls be destroyed, together with their olive groves and trees of any kind. The task was not easily accomplished; but these properties, together with many of the works of art they contained, were indeed pulled down. Though some compensation was made, this self-protective act of destruction was far more damaging to the property of Florentine citizens than anything the enemy would inflict. Visible from within the city walls, these villas with their groves and gardens were so precious to the lives of the well-to-do that their destruction had not seemed credible. But in October and November the job was done. Stonemasons and laborers tore down the buildings, often urged on by the youthful owners. Every growing thing that might support the enemy was carried off to the bastions, which were momentarily verdant.[37] Of the destruction Carlo Capello, the Venetian emissary, wrote in October 1529 that:

one can not say truthfully that the farms of these gentlemen are the hostages of their enemies, for such have been the fires set to beautiful and rich buildings, both by enemies and by the owners themselves, that it is hard to say which is the greater, either the inhumanity and barbarity of the one, or the generous constancy of the other, and even if so vast a ruin can only cause grief, there is much larger contentment in seeing the greatness of the spirits and the readiness of everyone to put up with every harm, every danger in the conservation of liberty.[38]

He himself had urged this action, saying that "all riches lie in the preservation of public liberty, without which private possessions are not one's own."[39]

Francesco da Sangallo was placed in charge of fortifications during Michelangelo's absence, and there could no longer be any doubt of San Miniato's crucial importance. By slowly trenching forward, the imperialists had reached the heights of Giramonte, and at the end of October they placed four cannons there, all trained on San Miniato [see FIGURE 17]. The Florentines wrapped the campanile of the church in wool and mattresses, and the whole side facing Giramonte was walled up by a mountain of earth. From inside the top of the bell tower itself Lupo, the famous bombardier from Santa Croce, pounded the enemy with cannon fire. Michelangelo resumed command of the fortifications on his return, and he would have good reason to fear for his life, and to wish to leave Florence forever when the city capitulated.

THE SIEGE: INSIDE THE WALLS · Machiavelli had insisted that the ancient maxim that money provides the sinews of war was wrong. But in the siege of Florence, money meant everything; and, in what was also a civil war, scarcity of arms and the declining numbers of men subjected the city to divisive political forces. Despite selling the possessions of rebels, and the confiscation of private and public goods, and despite even voluntary sales of property, in the end the city could procure neither food nor arms or men. By June 1530, only the soldiers had more than bread and water.

In the early months of the siege it was still possible to go hunting to the north outside the city. Children went to school and attempts were made to keep the shops open. By March 1530, however, as enemy troops closed in, practically nothing was to be had. In May the Venetian ambassador reported on the mounting deaths from famine and the numbers of corpses in the streets: survivors relied on the poorest bread, the meat of horses, cats, and asses, and there was no oil nor any wine. Six thousand died

between mid-March and mid-April alone, as sickness claimed those reduced to drinking water and eating grass. Another report says the citizens were reduced to eating mice, owls, and swallows, as vegetable gardens sprouted on the rooftops. When Empoli, the vital supply post to the west, was sacked in June, the patriotic poet Luigi Alamanni wrote, "It seems that one of our eyes has been closed, through which we saw the opening of the way to our salvation."[40] Even so, the government could not bring itself to cast out six thousand or so refugees, or "useless mouths," and a symbolic expulsion of prostitutes was retracted at the last moment. The "certain and manifest ruin" of the city, repeatedly invoked by Baglione and Colonna, would not be avoided in this way.

Money was made through sequestrations, lotteries, and compulsory sales. But this production of wealth within the walls could not keep pace with months of inflationary siege, and cash was constantly needed to pay the mercenaries and to procure weapons. On 9 June, even as the enemy burned all the pasture for two miles around the city, the Signoria finally passed a resolution that all gold and silver in private hands must be given over to the mint, and none was to be held privately for three years: the Florentines could live without these precious metals, if not with the same style, or *ornamento*.[41] In emulation of ancient republics, the men and women of Florence would offer everything in the preservation of liberty, the most precious possession of all. So eager were the citizens to support this measure they produced 120,000 ducats of gold, six times what the Signoria had hoped for, and from this metal, and from the church plate confiscated later, the republic struck new coins bearing the cross and the crown of thorns, and inscribed *Jesus Rex Noster et Deus Noster* (Jesus our king and our God).

Among the very few items that were specifically excluded from this resolution were certain medical utensils, the picks used for cleaning harquebuses, and (of particular interest with regard to our *Halberdier*) "medals made to be worn in hats or old medals."[42] No knight or doctor, however, was to be exempted from the provision against keeping worked or unworked gold and silver at home, though foreign soldiers were. Everyone was to be diligent in identifying cheaters, and no one could claim ignorance of the law.

THE SIEGE: SOLDIERS AND MILITIAS · The imperial army gathered outside the walls under its captain-general, the twenty-seven-year-old Philippe de Chalon, Prince of Orange, was an assortment of mercenary troops seasoned in war. When the

prince arrived with his army in August 1529, he had under his command a force of German landsknechts and Italian mercenaries, but all so poorly paid that they might desert to the Florentines at any time. He could lay siege to the city only upon the arrival of his Spanish infantry with pieces of artillery. As his army grew (perhaps to as many as 30,000), so did the need for supplies. Chronic shortages of arms and money made it impossible to contemplate all-out engagement, even if the emperor and the pope had wanted it. The pope was slow to produce funds, and Orange often gambled away what little he had. By the spring of 1530 it became clear that this war would be won by hunger rather than weapons, and the troops were reduced in number. Plenty were retained, however, and, after the surrender of the city in August, battles broke out over pay. Florence was forced to buy off the mercenaries to escape the sack they had been promised.

One reason Cosimo de' Medici's father, Giovanni delle Bande Nere, was revered in Florence was that military prowess such as he had possessed was conspicuously lacking among Italians. Florence was a city of merchants, not soldiers, and the quality of *civiltà* was cultivated over military virtue. Machiavelli complained that while others grew mighty in arms, the princes of Italy had thought it sufficient "to know how to write a beautiful letter, to show in sayings and words sharpness and quickness of wit, to know how to deceive, how to embellish themselves with gems and gold, to sleep and eat with greater splendor than others," and in general to lead a life of ease and pride.[43]

In Florence, ideally a republic without a prince, the problem of defense was always at issue: whether to buy unreliable protection with the profits of trade, or whether to embark on self-defense, which might unleash armed forces at home. Machiavelli had no doubt that the answer lay in a civilian militia on the ancient Roman model. However, the humiliating defeat of the militia companies raised by Machiavelli for the defense of Prato in 1512 destroyed all hope that Florence could survive without foreign troops. Moreover, the fear of arming the city's youth and its laborers persisted, as did the parallel fear of appointing a military leader from within the city.

THE SIEGE: *BELLA GIOVENTÙ* · The story of the last republic, beginning with the *Tumulto del venerdì* and ending with Malatesta Baglione's refusal to engage in final combat, is also the story of the reluctant acceptance by the Florentine establishment of the fact that citizens would have to bear arms, and the consequent increase in the status of youth—such young men as Pontormo's sitter. That this in turn led to a shift in political

power was one reason the city was eventually overcome by divisions from within.

The troops Malatesta Baglione commanded in defense of the Florentine republic were also mercenaries. Many, like those in the opposing army, were formerly members of the Bande Nere. Exiles were offered forgiveness if they returned to fight without pay, and many did. Only one-fifth of the commanders were Florentine, and all soldiers (unlike our *Halberdier*) were to wear a white cross on their uniform to distinguish them clearly from the enemy, whose identifying cross was red. Almost half of the entire force was regularly stationed at San Miniato al Monte.

The intention of the pope and his surrogates all along may well have been to avoid combat in and around the city, but the Florentine government could not know this, and even the loyal troops of the Bande Nere did not reassure them. The war council considered calling upon the Swiss or even hiring landsknechts because "we need to use people like them, and with the same weapons."[44] How much less likely to succeed was an untested citizen militia! Yet the creation of such a group became unavoidable. Even if Florence could not win in battle, an armed citizenry could at least keep civil order within the walls, and the republic might survive the siege through its own virtue under divine protection. The *Tumulto del venerdì* had been led by young men demanding arms, and late in 1527 a group of *giovani*, suspicious of Niccolò Capponi's relations with the pope, seized Palazzo Vecchio and demanded to be allowed to guard the building. Faced with this de facto palace guard, Capponi first diluted its power by increasing its number, and then acceded to demands for a true citizen militia, by which the militants might be controlled.[45]

After authorizing the enrollment of men between fifteen and fifty on 12 October 1528, the Signoria decided the following month that all full citizens from eighteen to thirty-six should be sworn to arms in the militia.[46] The militias were to be organized among the sixteen districts called *gonfaloni*, four in each of the quarters of Santa Croce, Santo Spirito, Santa Maria Novella, and San Giovanni. In November 1529 the age limit was raised to fifty, and in March 1530 to sixty. Only in the very last weeks of the siege was it agreed that even those ineligible for political office should be armed. Only then did the city arm its artisans, though the peasants who had taken refuge within the city were never entrusted with arms. By the end of the siege some ten thousand militia could be counted.

Under the command of Stefano Colonna the militia patrolled the streets and guarded the fortifications at night. They were capable of acts of daring, including

the famous nighttime sorties under Colonna's command of militia and soldiers combined. Known as *incamiciate*, from the white shirts the men wore over armor in the darkness, these raids were bloody and demoralizing to the enemy.

In its first real test, the new militia sprang to the defense of the city with great success. On the eve of the feast of Saint Martin (10 November) in 1529 the imperial forces, hoping to surprise the citizens as they celebrated the vintage, attempted to scale the walls. Carlo Capello described the event in one of his dispatches to Venice:

> This night around six they attacked the whole stretch from San Niccolò as far as San Frediano, with ladders and with great force. But their attack was immediately rebuffed by the vigilant and sprightly guards [*vigilanti e gagliarde guardie*], and in a moment the whole city was up in arms, and each in his proper place without any noise, even though it was raining hard and very dark. The enemy, to their shame, were forced to withdraw.[47]

Despite the frequent changes in the upper age limit, the militia was a force of youth, and to many this was regrettable; resistance to arming the *gioventù* was as much intergenerational as it was political. In Renaissance Florence the young men, or *giovani*, constituted a specific class. Like their fathers and grandfathers these young men still married late and were prohibited from taking important political office until they were thirty. The social and political status of the *gioventù* under the republic was indeed not much changed from the days of Lorenzo the Magnificent fifty years before. After crossing the threshold from boyhood to youth, well-born young men had plenty of money and little to do, and they often fomented political trouble as a result.[48] The last republic would make courtiers of some, send others in exile, and leave many dead. But Florence would never again be governed by older men who made money and practiced *civiltà* while paying others to fight their wars.

The refashioning of the *gioventù* was accomplished through the practices of civic ritual, as Richard Trexler has argued so forcefully. On the feast of San Giovanni (24 June) in 1529 (when the fifteen-year-old Francesco di Giovanni Guardi had just reached the age of eligibility), for example, some 2,800 youths in uniform paraded through the city for a mock battle at Ognissanti. Orations were given in each quarter on 9 February, the feast of the election of Christ as "King of Florence," and on May 15, the eve of the anniversary of the expulsion of the Medici. On these occasions the militia

companies appeared, ready for battle, in the quarter churches and in the Sala del Gran Consiglio in the Palazzo Vecchio. In orations, all given by young men in their twenties, the *bella gioventù* were praised for gallantly placing themselves in danger "to save our sweet liberty," as Piero Vettori put it, "and give vent to a just ire against the enemy."[49]

The oath-taking of the *bella gioventù*, inducting them into the militia at the age of eighteen during the feast of San Giovanni, was a focal ceremony of the last republic. It was staged between the Duomo and the Baptistery at a silver altar weighed down by sacred relics, and the *giovani* marched to the ceremony from each *gonfalone*, carrying flags with their neighborhood emblems on a field of green, the color of youth and hope.[50] In descriptions more reminiscent of the days of jousts and chivalry than those informed by the horrors of artillery warfare, witnesses recalled the beauty of these processions and the sumptuousness of the costumes and weapons of the *gioventù*.

That the final battle and the total destruction of Florence was proposed and then averted reveals the tensions such rituals were designed to conceal. We have already noted the broad divisions in the city: the *Palleschi*, or, Medici supporters; the group of *Ottimati*, who had been alienated from the Medici but were essentially conservative; the Savonarolans, who were most of all anxious to restore the republic; and the smaller group of several hundred *Arrabbiati*, who, inspired by the elderly Baldassare Carducci, were committed to more radical change and included members of the *Arti minori* (lesser guilds), as well as several hotheaded members of the patriciate.

Niccolò Capponi, the Savonarolan patrician elected gonfaloniere in 1527, could command the respect of most of these groups. But when he was ousted in 1529, tumult again threatened to turn into riot. Upon the election of Francesco Carducci as gonfaloniere, the militia was called to guard the Palazzo della Signoria, and the *gioventù* came together to defend the new regime.[51] While Capponi's fate was being debated and daggers were being drawn in the Sala del Gran Consiglio, his supporters, led by Cerotta Bartolini, confronted the crowd in the Piazza della Signoria. There Cerotta's brother, Lionardo Bartolini, who was one of the most impetuous of Capponi's opponents, shouted to him, "If you come forward I will be the first to break my halbard on your head."[52] Zenobi Bartolini, yet another member of the family that built Valfonda, and who served as commissary of the forces of the republic throughout the siege, would in the end support Malatesta Baglione at the moment of surrender. Such divided family loyalties, both within the city and without, were multiplied many times over. In times of civil war family names are not certain indicators of political commitment.

Many of these young men — including Capponi's own two sons; his enemy Pierfilippo Pandolfini; Bartolommeo Cavalcanti, who had given the most stirring of orations to the militia; and Girolamo Benevieni, still dedicated to the memory of Savonarola — had strong political and financial reasons to want to make peace with the Medici. Like their fathers they had come to see that the preservation of the city required an end to the war as matters took increasingly dangerous turns for the patriciate. If one revolutionary supporter of the republic could write that the two most dangerous qualities in a citizen were "being of great and noble family," and "substance and immoderate riches," then others might soon agree.[53]

Opposition to the war also brought opposition to the armed *giovani*. When Francesco Vettori was later advising Duke Alessandro de' Medici to disband the militia after the surrender, he claimed that they had been allowed to "eat and drink well, to dress beyond the laws, to have women and other things with more facility, to rule the roost at home, to incur debts without paying."[54] According to the Venetian ambassador, those who wanted change lived in such terror of them that they dared not speak out.

Change would be imposed from outside. Although Alessandro de' Medici's new title, Duke of the Florentine Republic, made a small concession to the past, it was nevertheless a hereditary entitlement. This son-in-law of the emperor, who governed by imperial patent and under the protection of imperial troops, held court as a prince. The youths who supported him enlisted in his personal service; those who refused would join their elders in exile. It would be the accomplishment of Alessandro's cousin Cosimo to bring back these exiles and to create a new kind of civil society governed through centralized dynastic power. "At the time of the siege," however, the time in which, according to Vasari, Pontormo painted the sixteen-year-old Francesco Guardi's portrait, it was not possible to know how all this would turn out. Nor was it obvious how any individual, whether a youth or his father or the painter commissioned to make the youth's portrait, would respond to the course of events. Even if we agree that the Getty portrait represents Francesco Guardi, we cannot as yet be sure of the relationship he bears to the wall he guards, which is to say his relationship to the Florentine republic.

"... HE ALSO PORTRAYED ..."

Could Pontormo have painted such an ambitious private portrait during the uncertainties inside the walls of Florence at the time of the siege, and why would he have done so?

We can document only one event in Pontormo's life at this time. This is his purchase from the Ospedale degli Innocenti of land on which to build a house in the Via Laura (now Via Colonna) on 15 March 1530.[55] The purchase indicates that Pontormo remained in Florence during the war, but we otherwise know little indeed about his experiences. In examining how some of his contemporaries comported themselves during the siege, however, we may come to see that the loyalties of artists were as varied as those of the population at large.

ARTISTS AND THE WAR · The sculptor Baccio Bandinelli, who took flight for the security of Lucca on the expulsion of the Medici, stands at one extreme as a Medicean creature who would prosper by the fall of the republic. Giorgio Vasari, on the other hand, was a citizen of Arezzo, born in 1511, and so not eligible for military service. He had come to Florence in 1524 under the protection of Cardinal Passerini and Ottaviano de' Medici. Vasari was in Florence during the *Tumulto del venerdì*, and describes braving the guards in Piazza della Signoria, together with his friend Salviati, to save fragments of Michelangelo's damaged *David*. On the expulsion of the Medici, Vasari withdrew to Arezzo. He returned to Florence in 1529, but fled to Pisa at the coming of the siege. Vasari, too, would later prosper under the Medici, although he missed few opportunities to record the trauma of the siege in the *Lives*. Benvenuto Cellini was a more complicated case. He returned to Florence after surviving the sack of Rome. Born in 1500, he was of an age to be called up immediately in 1528, and describes how he joined the militia "richly dressed," passing his time with the most noble people in Florence, "who were very ready to take up arms in the defense of the city."[56] He recalls how "the *giovani* spent much more time together than usual, and they talked about nothing else." It was, therefore, especially embarrassing when, surrounded by *giovani* in his shop, he received a letter conveying the pope's wish that he return to Rome. Cellini left town, essentially a deserter.

Also disloyal to the republic, apparently, was the sculptor Niccolò Tribolo. Even while the suburbs were being destroyed, Tribolo and his colleague Benvenuto Volpaia, working secretly at night, made a cork model of Florence for the pope—including the new fortifications at San Miniato—which was shipped in pieces to Rome in bales of wool. The project may have been inspired by the pope's desire to prevent the city and its monuments from being destroyed, a desire these artists surely shared. Tribolo would later thrive under Medici ducal patronage.

There can be no doubt that the siege changed Michelangelo forever. Like the pope, and like Tribolo, he must have wanted above all to protect the artistic fabric of Florence from the terrible fate of Rome. His father had left for Pisa, but his family and property in Florence remained under constant threat. Michelangelo had no interest in becoming a courtier of the new regime, and, after the siege was over, he left Florence, never to return.

Closer to Pontormo was Andrea del Sarto, who had been one of his teachers. Born in 1486, Sarto was in Florence during all the upheavals so far described. Worn out by the deprivations of the siege, he fell victim to the plague that broke out immediately upon the capitulation of the republic, and was buried in September 1530. The older painter was also more closely associated with the Medici regime. He had worked for the despised Cardinal Passerini, and he owed much to Ottaviano de' Medici, the general factotum of the family who took care of Medici possessions under the republic. Even allowing for Vasari's friendship with Ottaviano, his account of an encounter between painter and patron during the siege rings true. When Andrea tried to deliver his *Madonna and Child with Saint Elizabeth and Saint John* (the *Medici Holy Family*), Ottaviano told him to sell it, adding darkly, "I know of what I speak."[57] Shortly thereafter, on 13 October 1529, Ottaviano was confined to the Palazzo della Signoria, together with other Medici sympathizers, until the end of the siege. Andrea kept the painting for him and was rewarded doubly by Ottaviano on his release. Zanobi Bracci, another of Sarto's patrons, had already been imprisoned in February after his brother Lorenzo had gone over to the other side. Presumably Sarto's *Bracci Holy Family* remained in the possession of Zanobi's wife. Like many other great paintings of the period, always excluding the *Halberdier*, it found its way into the Medici collection. In this case the Bracci gave their *Holy Family* to Cardinal Ferdinando de' Medici in 1579.[58]

Unlike those artists who were outright Medici partisans, Sarto remained in the city during the siege. He probably served in the militia himself when the age limit was raised.[59] That he was fundamentally a patriot in the defense of Florence can be surmised from his remarkable drawings portraying traitors to the republic [FIGURE 19]. Three captains who had deserted to the enemy camp were hanged upside down in effigy at the gate of San Miniato, their faces turned toward the enemy at Giramonte. The effigies were made of rags and straw under Sarto's supervision, and Sarto's own drawings were apparently based on wax models made for him by Tribolo. They were preparatory

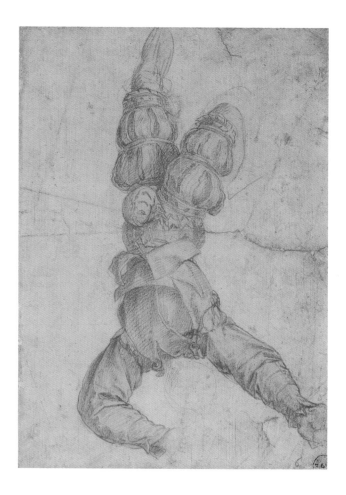

Figure 19
Andrea del Sarto. *Study of Effigy of Hanging Men ("capitani impiccati")*, 1529–30. Red chalk, 26.6 × 19.5 cm (10½ × 7⅝ in.). Florence, Galleria degli Uffizi (328F). Photo: Canali Photobank, Italy.

for a fresco that immediately appeared on the facade of the old Mercatanzia. The fresco was painted over after the siege, and only Sarto's drawings of the so-called *capitani impiccati* record this vivid, visual threat to the enemy and to any within the walls contemplating similar treachery.

Both Andrea del Sarto and Pontormo had reason to fear for the survival of their work during the siege. In the preemptive destruction outside the walls and the contemporary attacks by the enemy, Sarto fared remarkably well. The survival of his fresco of the *Last Supper* at San Salvi, beyond the Porta alla Croce, lends credence to Varchi's and Vasari's accounts that the wrecking crew was so overwhelmed by its beauty that they let it stand. Something similar seems to have happened in the case of the tabernacle with the *Madonna and Child with the Infant Saint John* [see FIGURE 13] just

outside the Porta a Pinti. Sarto's three altarpieces for the monastery of San Gallo, outside the gate of the same name, were saved together with other altarpieces from the church when the building was torn down.

Sarto was no less fortunate when it came to the activities of Battista della Palla, the hotheaded revolutionary who hoped to lure the French king, Francis I, into the defense of Florence by offering him astonishing gifts of works of art. Though many agreed to ship their finest possessions to France, Margherita Acciaiuoli, the wife of Pierfrancesco Borgherini, did not. The bedroom in Palazzo Borgherini was one of the most lavish interiors in Florence. Into wooden paneling designed by Baccio d'Agnolo were fitted pictures by Sarto, along with others by Granacci, Bachiacca, and even Pontormo. A staunch Medicean, Margherita's husband had taken refuge in Lucca, leaving her to take care of things at home. His brother Giovanni, on the other hand, married the daughter of Niccolò Capponi in 1526, and supported the republic. Such were the divisions of civil war. But Margherita's famous speech to Battista della Palla, in which she called him a "vile salesman, a little tradesman who sells for pennies" to embellish foreign lands and further his own self-interest, was from the heart, not a political theory.[60] She was ready to die defending her marriage bed and she stopped della Palla in his tracks. Giovanmaria Benintendi, who had a similarly ambitious decoration in his *anticamera*, with panels by Franciabigio, Bachiacca, Sarto, and Pontormo, seems to have been left alone, despite his Medici sympathies.

Not all works of art fared so well. Many perished in the destruction of the villas. The wax effigies of the Medici in Santissima Annunziata were destroyed, and we have already mentioned the attack on the epitaphs in San Lorenzo. Pontormo had more than a little to be concerned about. Early in 1529 the Sala del Papa in Santa Maria Novella was requisitioned to house the destitute. Pontormo had filled the chapel with Medici emblems in a frescoed decoration for the meeting between Leo X and Francis I in 1515. These seem to have survived without serious damage. At the monastery of San Gallo, on the other hand, Pontormo's frescoed *Pietà* was not spared. His portrait of *Cosimo Pater Patriae*, commissioned by the hated Goro Gheri of Pistoia, who ruled Florence as chancellor between 1516 and 1520, bore an inscription referring to the very title that anti-Mediceans wanted to have stamped out. The portrait's survival was probably due to its having passed to Ottaviano de' Medici, whose possessions were protected during his imprisonment.[61] On the other hand, Pontormo's portraits of Ippolito and Alessandro de' Medici, mentioned by Vasari, seem to have disappeared. At the Medici

villa at Poggio a Caiano, under Ottaviano's supervision, Pontormo had perfected one of his most ambitious works, the fresco of *Vertumnus and Pomona* in the lunette of the *salone*, a room that also contained frescoes by Sarto and Franciabigio. More than ten miles outside Florence, Poggio a Caiano should have been safe from the destruction of the suburbs. But, after razing the Salviati villa at Montughi and the Medici villa at Careggi, both within the set limits, the *giovani* then attempted to destroy the Medici villa at Castello, some four or five miles outside the walls. They would have burned Poggio a Caiano if the enemy had not been too close, and if the Signoria had not taken steps to prevent it.[62]

Especially poignant was the danger to Pontormo's equally ambitious frescoes of Christ's Passion and his canvas of the *Last Supper* at the Certosa at Galluzzo. The painter had withdrawn there in 1523 to escape the plague, and into these compositions, produced in the silent safety of the Carthusian house, he introduced figures of soldiers based on models in German prints, especially Dürer's *Small* and *Large Passion* series.[63] When, in April 1530, the prince of Orange realized that he must prepare for a long siege, he too withdrew to the Certosa, which was now threatened by his own desperate men crying out for money. Plague suddenly appeared there in May, perhaps even introduced deliberately by the republic. In this tranquil place, where Pontormo had earlier escaped the pestilence, forty or so Germans died every day, and three of the six remaining monks died in a single night. The real destruction of property by the unpaid troops took place elsewhere, but Pontormo can only have been frantic to know about the fate of his work.[64]

In Florence Pontormo's greatest monument to date was the decoration of the Capponi Chapel in Santa Felicità, probably completed between 1525 and 1528, and commissioned by Ludovico Capponi, a cousin of the conservative gonfaloniere of the republic. It is difficult to establish what work Pontormo began during the days of the republic. According to Vasari, the *Madonna and Child with Saint Anne and Four Saints* [FIGURE 20] was painted for the nuns in the convent of Saint Anne at the Porta San Friano. In the lower part of the picture he added "a little image of small figures that represented the Signoria going in procession with trumpets, pipes. . . . And he did this because the painting was commissioned by the captain and family of the Palazzo."[65] Since 1370 the Signoria had gone in procession every 26 July to Sant'Anna in Verzaia outside the walls to celebrate the expulsion of Walter of Brienne, duke of Athens, on the feast of Saint Anne in 1343. This revolution had also come about as the result of a well-

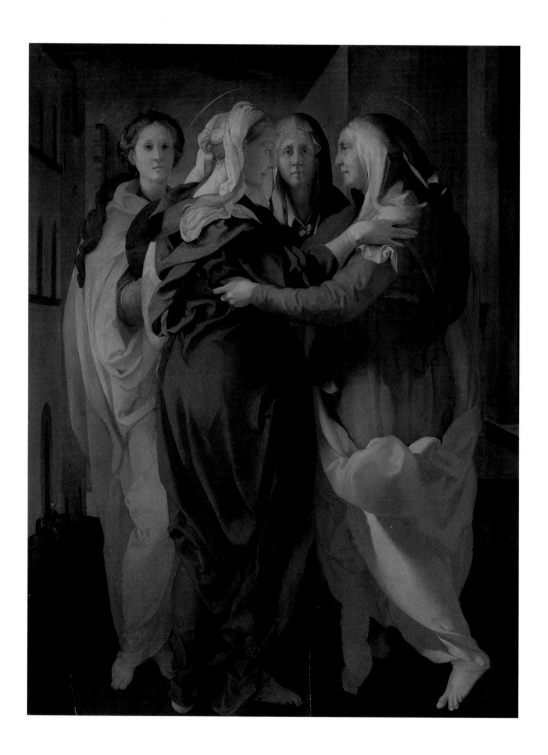

orchestrated tumult. After being invited to defend Florence, the duke had disarmed the citizens and expelled the Signoria, shredding the *gonfalone* of the *popolo*. Machiavelli's description of the events that followed is a set piece in the defense of liberty, and the parallels between his description of the expulsion of the duke of Athens and the *Tumulto del venerdì* could not have been more apparent.[66] Pontormo's altarpiece has been dated as early as 1524–26, following the order of Vasari's narrative.[67] For most scholars, however, stylistic evidence supports the likelihood that the altarpiece was commissioned by the republic in 1527–29 as a testament to its own parallel defense of liberty. In that case, the altarpiece may not have been delivered before the swift and total destruction of Sant'Anna. It would seem to be in accord with the politics of the gonfaloniere Niccolò Capponi, celebrating the continuity of Florentine devotion to liberty through moderation. There is no indication that the Sant'Anna commission sprang from any anti-Medicean commitment on Pontormo's part.

Such a sentiment would, in any case, be unlikely for a Florentine artist who had worked for the Medici, and who, like Andrea del Sarto, was probably more concerned with survival than with politics. Nevertheless, it has been suggested more than once, especially in connection with the Getty *Halberdier*, that Pontormo's works during the siege do reflect a specifically anti-Medicean stance. Much has been made, for example, of Vasari's failure to mention Pontormo's extraordinary altarpiece of the *Visitation*, now in the church of San Michele in Carmignano [FIGURE 21]. Generally dated on stylistic grounds to the late 1520s or 1530, the *Visitation* is also stylistically close to the *Halberdier*. Costamagna has conjectured that the *Visitation* was commissioned for a private chapel in Florence by Alessandro Bonaccorsi-Pinadori, who was later hanged by Cosimo I in 1540.[68] This infamy would account for the removal of the picture to a country church, and Vasari's silence. Yet Vasari may not have mentioned the picture simply because Bronzino, his best source on Pontormo, did not know about it either. Pontormo may have painted the altarpiece outside the city before the actual onset of the siege (we should recall his predilection for the peace of the Certosa here); or (and this is less likely) he may have completed it soon after, during the interim between 1530 and 1532 when Bronzino was in Pesaro.[69] Bronzino would later paint a portrait of one Buonaccorso Pinadori. Whether or not the Carmignano *Visitation* was painted for an anti-Medicean member of the Pinadori family is by no means clear, although Bartolomea Pinadori, wife of the the probable patron, was indeed the niece of Francesco di Filippo

del Pugliese. This passionate supporter of Savonarola had been exiled in 1513 for saying
of Lorenzo the Magnificent, "*el Magnifico merda.*"[70]

More obviously relevant to the question of whether or not Pontormo
would have expressed anti-Medicean sympathies in painting the *Halberdier* is the small
panel representing the *Martyrdom of the Ten Thousand* [FIGURE 22], now in the Palazzo
Pitti.[71] The story is itself military. According to the apocryphal legend published by Pietro
de' Natali in his *Catalogus Sanctorum* (Vicenza, 1493), the Roman emperors Hadrian
and Antoninus had sent Achatius and Heliades with a command of nine thousand sol-

diers to conquer one hundred thousand rebels in or near Armenia. An angel offered them the victory if they confessed in Christ. After the promised victory the men were led up to Mount Ararat, informed of their future martyrdom, and baptized. In consequence of their conversion the Roman emperors mounted a campaign against them. As Achatius and his men bore witness to their faith, they were stoned, but the stones were turned back. The emperors ordered that the Christians be flayed with spikes, but an earthquake stayed the hand and arm of the tormentor. Seeing this, another thousand soldiers converted. The enraged emperors ordered caltrops (three-sided nails used to cripple cavalry horses) to be spread on the ground and the believers made to walk on them with bare feet. Angels came to pick up the nails. Believing the angels to be gods, the emperors prepared to sacrifice to them, but the soldiers begged to be crucified in imitation of Christ. King Sapor, the local ruler, ordered them crucified or staked on Mount Ararat. The earth grew dark and there was another great earthquake. Then the mountain was filled with light, and the martyrs' bodies were taken down by the angels and buried. Pontormo's small, intense painting includes all these episodes, though he omits the two emperors.

Setting the *Martyrdom* off from Pontormo's earlier work is its salient Michelangelism. Pontormo had long studied the work of Michelangelo, especially the *Battle of Cascina* [FIGURE 23], from which he made drawings that date to the mid-1510s.

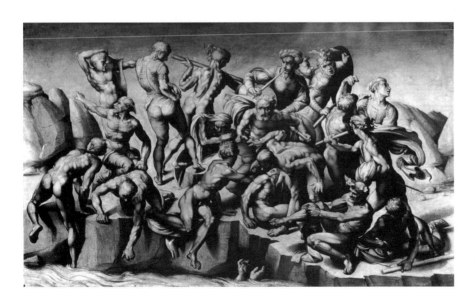

Figure 23
Michelangelo Buonarroti. *Battle of Cascina*, 1504–5. Copy by Aristotile da Sangallo, 1542. Grisaille on wood, 78.7 × 129 cm (31 × 50¾ in.). By kind permission of the Earl of Leicester and the Trustees of the Holkham Estate.

But now Pontormo quotes Michelangelo in his composition directly. The upper body of the figure draped in red among the crucified, for example, is derived from the turning figure with swirling drapery to the right in the *Battle of Cascina*; and the legs of the torturer in the foreground, seen from the back, are those of the standing figure attaching his hose in the same cartoon. Pontormo also adopts the muscularity of Michelangelo's figure style for the battle section of his painting, contrasting these heroic victors with the elongated bodies in the foreground, whose flesh sags from their defeated and scrawny frames. The captives look downward, upward, and out, with vivid and varied faces, some of which are clearly portraits that document the suffering of contemporaries of the young man portrayed in the *Halberdier*.

These stylistic references to Michelangelo have also often been taken as signifying criticism of the Medici. The case rests on a perceived reference in the figure of the king to Michelangelo's sculpture of Giuliano de' Medici for the Medici Chapel [see FIGURE 11]. If the cruel ruler looks like Michelangelo's figure of Giuliano de' Medici, then—so the argument goes—that figure must refer to the Medici, who brought about the torture of the Florentines during the siege. Yet Pontormo's powerfully commanding figure bears only a generic resemblance to the statue of Giuliano, and to concentrate exclusively on associations with it, is to ignore the ways in which Pontormo also refashioned figures from his own work in this small masterpiece.

This is not to say that the *Martyrdom of the Ten Thousand* has no political content. Muscular men conquer under the protection of angels. Now bowed and wasted, they are punished in the name of empire. Saved again by angels, they embrace the sacrifice they desire. In the meantime a company of modern soldiers, armed for combat and carrying a red banner, arrive to witness a scene that will lead them also to convert. An angry figure of authority (King Sapor, the imperial surrogate) condemns the martyrs to further punishment. The entire story takes place in a blasted and empty landscape. Its scenes of battle, the reinforcing soldiers in contemporary armor, the abject helplessness of the prisoners, and the final martyrdom are all brought together in a way that makes it hard to resist seeing in this consummate panel Pontormo's stark response to the suffering and vindication of a city that was dedicated to Christ and prepared to suffer extinction in its resistence to the forces of imperial tyranny.

Although the *Martyrdom* is not documented, Vasari reports that it was painted for the "women of the Ospedale degli Innocenti," and that Vincenzo Borghini, in his day the director of the hospital, held it in great esteem.[72] Pontormo may have

painted the panel in connection with purchasing property for his house and studio from the same hospital in March 1530. The name of Saint Achatius (deriving from the spiny acacia tree, and hence the stories of flagellation with spikes and walking on caltrops) was especially invoked by those on their deathbed. Almost without interruption, plague or war ravaged Florence throughout the 1520s. That Pontormo shows the flagellation about to be stopped might suggest that plague is the immediate pretext for his painting, but war, which brings its own manifold torments (including plague), lies at the heart of Achatius's story. When Florence dedicated itself to Christ the King, the crown of thorns was placed on the Palazzo della Signoria and on the shield of the republic. Florentines had long claimed descent from Noah, tracing their origins to the survivor of the flood who landed on Ararat, site of the martyrdom of Achatius and his followers. They too were now prepared to make their final sacrifice in Christ's name as his chosen people. Should all human endeavor fail, they believed that angels would appear with Christ to repel the enemy from the city's walls, just as they come to the aid of the faithful soldiers in Pontormo's painting.[73]

This small panel of the *Martyrdom of the Ten Thousand* thus provides a bitter commentary on the sufferings of the Florentines at the hands of imperial forces during the siege. It does not, however, have to do with specifically anti-Medicean factionalism as such. For the nuns at the Ospedale degli Innocenti the horrors of death were more pressing than politics. For Pontormo, fears of death and the possible destruction of his work, should the city suffer the same martyrdom that befell Rome during the sack, were very real in 1529–30.

After the siege Pontormo was as much at the mercy of the Medici as was Michelangelo. The close relationship between the artists is documented by two joint projects from 1531–33. These are the *Noli me tangere* for the imperial general Alfonso Davalos, and the *Venus and Cupid*, originally for Bartolomeo Bettini, but acquired by Duke Alessandro de' Medici. In both cases a full-scale drawing, or cartoon, by Michelangelo was translated into paint by Pontormo.[74] It would be difficult to date Pontormo's *Halberdier* after these two collaborative works with Michelangelo, the massive and elongated figures of which are prophetic of such later projects as Pontormo's 1537 frescoes at Castello and the frescoes in San Lorenzo. When Michelangelo left for Rome, his colleague remained in Florence, essentially a Medici creature. Apart from one or two remarkable portraits, Pontormo's last twenty-five years were taken up by Medici commissions.

Pontormo was thirty-five when the siege began. Like Cellini and Andrea del Sarto, he would eventually have been mustered into the militia. Like them, and like many other Florentines, he must have undertaken this duty with reluctance. He was neither so staunchly Medicean nor so cowardly that, like Bandinelli, he fled Florence. His purchase of property and the melancholy vision of the *Martyrdom of the Ten Thousand* support the conclusion that he stayed and suffered. The Louvre *Madonna and Child with Saint Anne and Four Saints* and the Capponi Chapel commissions suggest his association with moderate republicanism through Niccolò Capponi himself. But his work was not so closely identified with opposition to the Medici that, like Michelangelo, he had to escape afterward. In sum, we should not imagine Pontormo as a radical, immortalizing a young man fighting for liberty in the Getty portrait. The hypochondriacal personality, preoccupied by fears of death, that Pontormo's friends described at the end of his life may have been formed during his precarious, orphaned youth. But it can only have been confirmed by his experience of the siege.

Figure 24
Arms of the Guardi del Monte Family. Archivio di Stato, Florence, Priorista Mariani, vol. 6, fol. 1402v. Photo: Nicolò Orsi Battaglini.

"*. . . F RANCESCO G UARDI . . .*"

Francesco Guardi was born on 29 April 1514. He was the first child of Giovanni di Gherardo Guardi and his wife Diamante, of the Guardi del Monte family [FIGURE 24] from the *gonfalone* of Ruote in the quarter of Santa Croce in Florence.[75] The Guardi were a large clan, including generations of sons named Francesco, and this has made the identification of the sitter for Pontormo's portrait quite difficult. It was long thought that Vasari's reference could only be to a much older Francesco di Battista Guardi born in 1466, who was elected to the priorate in 1529. This Francesco could not, therefore, be identified with Pontormo's much younger man "at the time of the siege . . . in the costume of a soldier." Francesco di Battista came from the Guardi del Cane family in the *gonfalone* of Lione Nero, also in the quarter of Santa Croce. The two families were often close neighbors in the city and at Terranuova, where they had estates. Several other loose connections can be established in the close-knit Santa Croce neighborhood, and both families had their tombs in Santa Croce itself.[76] But they had quite separate identities. The Guardi del Cane in Leone Nero, for example, held political office quite frequently in 1527–28 under the republic. The Guardi del Monte from Ruote did not. They had been elected to the priorate with some frequency in the previous century, beginning with Francesco's great-

uncle Guardi di Lapo Guardi (in 1443), and his
great-grandfather Andrea di Lapo Guardi (in 1445
and 1453). His grandfather Gherardo held office four
times. With the exception of his last turn of duty in
1497, all of these offices, and those of other members
of the immediate family, were held under Medicean
rule. Whereas the Guardi del Cane were associated
with the guilds of the merchants and the woolwork-
ers, several early members of the Guardi del Monte
family belonged to the woolworkers' guild, and yet
others to the lesser guild of the strapmakers.

In the two generations preceding the
birth of Francesco di Giovanni the family had con-
structed important social and economic networks
that helped it to advance in Florence. Giovanni's aunt
and uncle had both married into established fami-
lies, Marietta marrying Amerigo da Verrazzano in
the immediate neighborhood of Santa Croce, and
Francesco marrying Brigida Pitti. Giovanni's father,

Figure 25
"Il Palagietto," the Guardi
palace on Via Ghibellina
in Florence.

Gherardo, had even greater opportunities to establish his extended family, for he mar-
ried three times and produced at least nine children. Each of his three wives, Piera Nicco-
lini, Talana Berardi, and Nanna Bartolini, brought important social standing, and Gherardo
consolidated that standing by arranging good marriages for his daughters in the della
Vigna, Davanzati, and Altoviti families.[77] Gherardo's son Branca married Alessandra di
Amerigo Simone Carnesecchi. Giovanni's second wife, Francesco's mother, was Diamante
di Neri di Niccolò Paganelli.[78]

Giovanni Guardi's father and uncle, Gherardo and Francesco, both died at
the beginning of the sixteenth century, and their tax records reveal the pattern of prop-
erty ownership that would continue in our Francesco's day. They lived in a house in the
Via Ghibellina, where they had begun to assemble the property that would come to be
known as "Il Palagietto." Its facade was on the Via Ghibellina, and it was bounded at the
sides by the Via San Cristofano and the Via delle Pinzochere [FIGURE 25]. Like others of
their patrician class, the Guardi del Monte decided that they needed a prestigious palace
only some decades after the great Medici and Strozzi families. But unlike the latter, who

Figure 26
Buonsignori map of
Florence (detail), 1584.
Guardi properties
highlighted. Engraving.
Photo courtesy
of Kunsthistorisches
Institut, Florence.

LA MATTONAIA

IL PALAGIETTO

FLORENTIAE TOPOGRAPHIA ACCVRATISSIME DELINEATA
DELINEATA

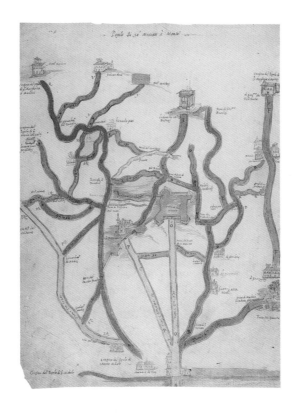

built from the ground up, the Guardi followed a more typical pattern of consolidating several properties into one. Nonetheless, the property in the Via Ghibellina was substantial enough for Benedetto Dei to mention it, together with the Palazzo Medici, the cupola of Santa Maria del Fiore, and the palaces of the Spinelli, Rucellai, Martelli, Canigiani, Capponi, and Neroni families, among the thirty-three great buildings in Florence around 1470. In 1481 the family reported spending "not a little" on this palace, but did not as yet live there.[79] The Guardi had several other houses, as well as numerous farms and landholdings, mostly at Terranuova. They also owned two important pieces of land closer to home. One was a large market garden in the parish of Sant'Ambrogio, where the family had first established itself at the end of the thirteenth century. This was just inside the wall near the Porta alla Croce in the area known as "La Mattonaia" [FIGURE 26]. Like Valfonda it was an extent of productive land, where grain and vines were tended. The other Guardi property was also a farm, this time in the parish of San Miniato. The place was called "La Piazzuola" and was bounded on all four sides by roads [FIGURE 27]. It could not support a farmer (producing less grain than the garden

Figure 27

Map of the area around San Miniato showing the Guardi property, La Piazzuola. To the right of the "Fortezza da San Miniato" in this orientation, "Guardi" is inscribed at the meeting of roads "C" and "D"; beyond, at the right edge, is "Giramonte." Archivio di Stato, Florence. Capitani di Parte—Popoli e Strade, vol. 121, fol. 24. Photo: Donato Pineider.

at La Mattonaia, but more wine and some oil), and so could not be rented out. Pieces of the wall had to be repaired every year.

Like the Riccardi much later in the century, the Guardi del Monte attempted to maximize their wealth and standing by keeping the family properties together through the device of the *fideicommisso* (trust). Affirming inheritance through male descent, Gherardo d'Andrea Guardi prohibited the alienation of family property.[80] He was unable to make his will officially before his death, but on 20 February 1503 his sons testified to their understanding of what had been agreed. Soon afterward, in September 1504, their father's brother Francesco also died and was buried in Santa Croce. Francesco seems to have had no direct heirs. Piero, Giovanni, and Branca therefore made a private agreement that was only registered in May 1510, several months after Branca's death.[81] Giovanni's most important acquisitions in this division of property were the house his father, Gherardo, had lived in, the new house at Terranuova, and the farm at San Miniato. The latter he would not receive until the death of his mother, Nanna, and when he did, he would have to pay some compensation to his brothers. Piero was to get his uncle Francesco's house, other houses in the Via delle Pinzochere and the Via Ghibellina, in addition to a new house outside the walls. Branca received the palace in Via Ghibellina, as well as the garden property at La Mattonaia. All three brothers inherited pieces of productive farmland.

When Branca di Gherardo made *his* will in 1509, it seems that none of the three brothers had as yet produced a male heir. Branca therefore tied the palace in the Via Ghibellina and the market garden at Sant'Ambrogio in trust. Giovanni and his heirs were never to sell either of these, and, should the male line die out, the properties were to go to the Ospedale degli Innocenti, the charitable institution from which Pontormo was to purchase the property for his house, and for which he painted the *Martyrdom of the Ten Thousand*. The hospital was also bound not to sell these properties. The market garden near Sant'Ambrogio, together with its main house, Branca wanted to have serve as a retreat for the boys and girls of the hospital and those who served it. Otherwise he named his wife, Alessandra Carnesecchi, his universal heir. Branca di Gherardo died in 1509 and was buried in Santa Croce.

The following year Branca's brothers Giovanni and Piero brought suit against his widow and the Ospedale degli Innocenti. Piero's claim was that the part of Branca's estate that had come from his father's trust did not belong to Alessandra and

moreover could not be subjected to a new trust by Branca. The court agreed, taking care to exclude Alessandra's dowry from the Guardi property.

Piero also died without an heir, on 9 July 1526, and a similar situation arose when it turned out that he had left his possessions to the Ospedale di Santa Maria Nuova. Giovanni di Gherardo, the father of Francesco Guardi and now the sole heir of his father's trust, appealed to the magistrates in 1529. The case was decided by none other than the radical republican gonfaloniere Francesco di Niccolò Carducci and by Girolamo Inghirlami in one of the last civil judgments before the city was besieged.[82] Their major decision was that the house in Via Ghibellina that Piero had received in his parcel of his father's goods must come to Giovanni, together with all of its furnishings. In return Giovanni had to pay Santa Maria Nuova a sum of money to be decided by the judges. Giovanni also had to agree that everything else Piero might have given to the Santa Maria Nuova remained the property of the hospital. The fee decided upon in this compromise was 550 gold florins, with two hundred to be paid by Giovanni within two months (by around 20 October 1529), and the rest within a year. What a year that would turn out to be!

In August 1529, on the eve of the siege, through a series of twists of fate, all the properties held in the trust set up some twenty-five years earlier by Gherardo di Andrea Guardi returned to a single owner, Giovanni Guardi, the father of our Francesco. Under the jurisdiction of the republican gonfaloniere, who took office only in April 1529, but who had immediately and systematically set about punishing supporters of the Medici, Giovanni recovered the rights to the last of his brothers' shares of the estate. He and his family had defended their interests against two of the most powerful charitable institutions in the city, the Ospedale degli Innocenti and the Ospedale di Santa Maria Nuova. And in addition to the great good fortune of having outlived his brothers, Giovanni had what they did not—a male heir, then in his sixteenth year. At this point in our argument we begin to see the motive for the Guardi family's commissioning of such a significant portrait.

One year after our Francesco di Giovanni was born, his prudent father made a will. On 3 March 1515 he left everything to his son, and to any future sons he might have with his wife Diamante. The will would, then, cover the inheritance rights of Gherardo, Francesco's brother, who was born in 1520.[83] Should all his male heirs die, then Giovanni wanted his possessions to pass to Maria, his daughter by his first wife,

Lucrezia, and to any further daughters he might have. Should they die without heirs, then they would be replaced in his trust by his nephews, the sons of his sisters Ginevra and Lucrezia. Fortunately, when Giovanni died on 15 January 1533, he had two sons to carry on the family name. Francesco was then eighteen, and Gherardo twelve.

The story of the Guardi del Monte family is not sufficiently remarkable to have attracted the attention of historians; similar stories could be told about many Florentine families in the sixteenth century. Often their histories were left unwritten because these families died out before the need to establish patents of nobility in the seventeenth century led to a passion for genealogy. The Guardi del Monte line was indeed extinguished in the seventeenth century in the generation of Francesco's brother Gherardo's great-grandchildren. But in late 1529 there was every reason to commemorate the appearance of this young man, whose circumstances meant that, for one brief moment, he might be seen to stand out from, or more truly *stand for*, others of his generation and class. Yet without Pontormo's gallant vision of the *bella gioventù* Guardi represented, and without Vasari's mention of his "most beautiful" portrait, Francesco di Giovanni Guardi would have been lost to history, except for the bare records of his birth and taxes.

Pontormo's extraordinary success in conveying the complexity and tensions of that moment of history, which still resonate in the very different responses the portrait evokes, led Mather to conclude that the sitter's name was less important than his beauty, his state of mind, and the object of his gaze. But only by examining the history of the Guardi family and its fortunes, especially in the months before the onset of the siege, can we begin to see how fundamentally important these might be to the portrait. We can at least now understand some of the reasons why Francesco Guardi's father might have wanted to celebrate his good fortune by recording his oldest son and heir's appearance in that fateful year of 1529. Before going further, however, we need to look more closely at this young man. What can his clothes, his weapons, and his jewels really tell us about the meaning of his appearance?

"... FRANCESCO GUARDI IN THE COSTUME OF A SOLDIER ..."?

The *Halberdier*'s costume is painted with great specificity. The young man wears a crimson cap to which a white feather is pinned by a badge. The red cap matches the modestly slashed breech-hose and highly prominent codpiece. His slender upper body is given

elegant substance by a thickly padded *giubbone* (doublet), buttoned down the front and at the cuffs with covered buttons. This garment is creamy-white, shot with touches of pink, and probably made of taffeta, accounting for the fine folds in the sleeves. The young man's breech-hose are attached to the doublet with narrow ribbon points of the same color; several of the points are tagged with fine gold aglets. His codpiece, juxtaposed conspicuously to his sword, is of the same slashed fabric. Under the doublet he wears a white shirt, probably of silk, which ends in soft folds around the wrists; at the neck the fine, white thread ties of the standing collar are left undone. Around his neck the youth wears a simple gold chain, which casts shadows on the shiny surface of the doublet as it twists of its own weight. Around his narrow waist, finally, the *Halberdier* wears a plain leather sword belt, to which the scabbard of his finely wrought sword is attached at the right by straps. The chiseled pommel of the sword itself is topped with a gilded tagnut, or button, and the grip is wound horizontally with wire.

The subject's other weapon is the so-called halberd, identified in the Riccardi inventory as a pike. What is this weapon? The pole is made of a deliberately grained sturdy wood, and at the level of the sitter's eyes is a black covering with a frilled edge. Pikes were often decorated with such tassels at the meeting of the head with the shaft, and by the sixteenth century their length had shrunk considerably, especially when used for ceremonial purposes. Battle pikes, on the other hand, were still very long—about eighteen feet. Furthermore, we would expect a pikeman to be protected by armor—at least a breastplate—even in a ceremonial context.

The writer of the inventory probably used *picca* as a generic term for a pole arm, a class of weapons that included many exotic forms with colorful names—the Bohemian Ear-Spoon, Fourche à Crochet, Langue de Boeuf, Halberd, Partizan, and Bec de Corbin—all designed to inflict maximum pain and injury. The weapon portrayed by Pontormo could be a pike, but is in fact more likely a halberd, as Mather intuited. Such weapons were still taken into battle in Pontormo's day, but they were of little use against powder, and increasingly they too were used only ceremonially.

Only the essential woodenness of the pole is insisted upon, together with the black fringe and cover that distinguish it as a weapon. While Pontormo chose not to document the precise nature of this weapon, it is clear that the young man is not dressed for battle. The surprised soldiers in Michelangelo's design for the fresco of the Battle of Cascina rush to pull up their hose and truss their points [see FIGURE 23]. Pontormo's elegant figure would probably have had a servant to help truss his; his

doublet has no points for the attachment of pieces of armor and is made of a fine fabric that would offer very little protection, even if padded. The gold chain reinforces the impression created by the expensive rapier and golden hat badge, that the young man before us may be all dressed up in military finery, but that he is not about to fight. He is only, as Vasari says of Francesco Guardi's portrait, *in abito di soldato* (in the costume of a soldier).

The *Halberdier*'s costume has been cited in support of the identification of the sitter as Cosimo I. In the 1989 sales catalogue Cox-Rearick observed that the youth's dress is not typical of the middle or even late 1530s, but recalls the brightly colored costume of past republican times, and she then proposed that Cosimo is dressed in nostalgic imitation of his father, the great soldier Giovanni delle Bande Nere, perhaps even wearing some of his clothes. At the same time she claimed that this costume should be associated with the outfits worn by landsknechts—those mercenary soldiers brought to Italy by the emperor Charles V from Germany and Switzerland. In support of this double theory Cox-Rearick referred to contemporary stories that the young Cosimo liked to go about dressed as a knight, often courted by his father's supporters.[84] Reportedly, Clement VII sent a message to Duke Alessandro that young Cosimo must stop wearing "foreign attire," apparently because, when Cosimo returned to Florence in 1531, he wore the military dress to which he had been accustomed. He was advised to appear less anxious to aspire to his father's prowess.

None of this testimony helps us very much, for there is no reason to identify the *Halberdier*'s costume as that of a landsknecht. Most characteristic of that costume were long ostrich plumes in the hat, complemented by extravagant slashing of the clothes and a prominent codpiece. More often than not the mercenary landsknecht, a commoner who relied on looting for his livelihood, sported a ferocious beard and mustache and wore mismatched hose. He indeed often carried a sword and halberd, and is occasionally depicted with pieces of light armor and adorned with the heavy gold chains in which he invested his booty, the more easily to carry his wealth about with him [FIGURE 28]. By contrast, the beardless young *Halberdier*, despite his codpiece, displays none of the brutal qualities that made it worth paying a man to fight, and his elegant costume conveys none of the exaggerated panache of the mismatched gear of a ruffian far from home, a type with which Pontormo was all too familiar in both his life and art.

The landsknecht proposal carries the implication that there is no further need to consider the pole arm held by this dazzling young man. Yet this humble wooden

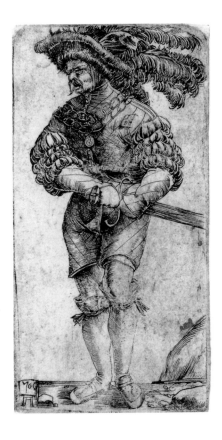

pole, presumably the weapon of a foot soldier, stands in such strong contrast to his elegant sword and costume that it demands further explanation, especially if he is Cosimo de' Medici. As the eminent historian Nicolai Rubinstein has observed, it is inconceivable that the young duke would have had himself portrayed in 1537 with so little dignity.[85] In the 1989 sales catalogue essay, however, the apparent incongruity of Cosimo I as a foot soldier passed unnoticed, as did the fact that in Florence in 1537 the image of a landsknecht could only serve as a reminder of foreign invasion and the horrors of war.

Moreover, we also have some sense of how the young Cosimo de' Medici dressed when he returned to Florence after the siege. Ridolfo Ghirlandaio's 1531 portrait was, as mentioned earlier, the model for Vasari's frescoed image in the Palazzo Vecchio [see FIGURE 9]. It shows the twelve-year-old Cosimo in a fur-lined, short military costume, far more splendid than that worn by the *Halberdier*. This would have been the sort of dress to which Clement objected in the delicate political situation after the siege.

Figure 28
Albrecht Altdorfer
(German, circa 1485–
1538). *Landsknecht
about to Draw His
Sword*, 1506. Engraving.
Cambridge, Fitzwilliam
Museum, University of
Cambridge.

Interestingly, Ghirlandaio's portrait does not show Cosimo wearing the gold hat badge and chain that we know Maria Salviati asked her husband to buy for their four-year-old son in 1523.[86] In his first years in power Cosimo preferred to wear brown or gray.[87]

In response to claims that the *Halberdier*'s costume resembles that of a landsknecht, Berti drew attention to Sarto's drawings of hanging men [see FIGURE 19]. These figures wear the same kind of slashed breeches with attached codpiece that Pontormo's sitter wears, and Berti went on to cite the diarist Lapini's report that it was fashionable in Florence *precisely* during the siege for young men to wear their hair short, rather than shoulder-length, and with a beret. He also cites the statement by the historian and poet Benedetto Varchi that during the siege the Florentine *gioventù* made a great spectacle because "they were no less practically armed than they were magnificently dressed," and that many of the young militia bore pole arms, whether pikes, halberds, or partizans.[88] It might be objected that many figures in Pontormo's earlier work already wear their hair short, and that every army had men with pole arms, but such contemporary evidence powerfully supports the view that this young man is depicted "at the time of the siege . . . in the costume of a soldier." His hair is short and he carries a simple pole arm, prepared to defend himself in close combat by heroic means. In his cap is a hat badge of high quality, and the sumptuous costume and expensive sword establish that he is not truly a soldier, as does the absence of body armor. Instead he wears the very outfit of *giubbone*, slashed breech-hose, and beret with medal and feather that was prescribed for the militia by the Signoria in the legislation of November 1528; the sword was prescribed for nighttime duty.[89] As Berti wrote, he is one of those magnificently dressed members of the *gioventù* whose company Cellini found so enjoyable.

Mention of Cellini, and comparison with Sarto's drawings of the *capitani impiccati* should remind us, however, just how difficult it is to establish fixed political loyalties in a civil war. To accept Berti's view that the *Halberdier* is the portrait described by Vasari of Francesco Guardi dressed up as a soldier at the time of the siege, and knowing that at that moment Francesco was heir to the newly consolidated Guardi properties, does not fully establish his role or position, or the complexity of the circumstances that produced this remarkable image.

THE HAT BADGE · Pontormo also depicted the hat badge [FIGURE 29] in such a precise way that it too demands our attention and understanding. The long silver pin ends in a ring, to which the three linked circles connecting it to the badge itself are

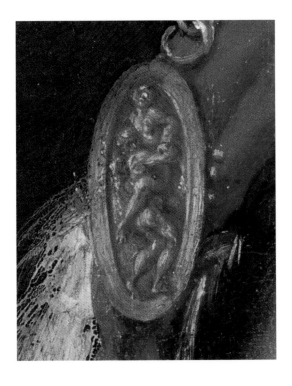

attached. A flash of silver where the hat's crown and rolled edge come together shows with what care the pin has been stuck through the woolen fabric; fully one-third of the hatpin projects beyond the edge of the hat into the sitter's curly brown hair. Although the arrangement is clearly functional, allowing the owner to move the badge to another hat, it is also unusual. In other painted or engraved examples hat badges are sewn on or affixed by clasps. However, the theme of Hercules and Antaeus shown on the badge is by no means unusual. In 1512, for example, Federigo Gonzaga wrote to his mother, Isabella d'Este, describing a medallion by Caradosso showing Hercules overcoming Antaeus, "beautifully made entirely with the hammer."[90] The same subject appears in a design for a hat badge by Ambrosius Holbein [FIGURE 30].

The *Halberdier*'s badge is oval rather than round, following the most up-to-date fashion. Pontormo has conveyed a sense of deep sculptural relief through brilliant highlights, by crowding the small space with the two muscular figures, and by implying that the right foot of Hercules projects outward, the heel overlapping the border of the badge. The story of Hercules and Antaeus concerns the hero's defeat of the Libyan giant who challenged everyone he met to a wrestling match. Because Antaeus was the son of

Figure 29
Pontormo. *Portrait of a Halberdier.* Detail of hat badge.

Figure 30
Ambrosius Holbein (German, circa 1494– circa 1520). *Study for a Hat Badge Showing Hercules and Antaeus,* 1518. Pen and ink, DIAM: 6.4 cm (2½ in.). Karlsruhe, Staatliche Kunsthalle (VIII 1626).

the Earth, he had indomitable strength (which throwing him to the ground only served to increase), and he killed all those he vanquished. Recognizing the source of Antaeus's strength, Hercules defeated and killed him by lifting him off the ground.

Interpreters of Pontormo's portrait, of whatever faction, have focused on the Florentine associations of this image within the image. Hercules, emblematic of *virtus* (literally, manliness), already stood for Florence and for Florentine virtue in the late thirteenth century, when the seal of the commune bore his figure to signify the defeat of tyranny.[91] The image held special meaning for Lorenzo the Magnificent, who owned, among other works devoted to the subject, a highly innovative bronze statuette by Pollaiuolo. In ancient models a bearded Hercules generally raises Antaeus up from behind, but Pollaiuolo rethought the relationship between the wrestlers. He shows the hero beardless, clasping the struggling giant's body frontally against his own.

The importance of Hercules in the political mythology of Florence made Pollaiuolo's interpretation especially influential. The figures on the reverse of the medals designed by Domenico di Polo for Duke Alessandro de' Medici in 1534 were loosely modeled on it. After Alessandro was murdered, his young cousin Cosimo I adopted the emblem for himself, and Domenico redesigned the image, keeping the same inscription. Cosimo's swift appropriation of Alessandro's personal imagery for the medal made soon after he became duke indicates his determination to suppress doubts about the legitimacy of his succession.[92] Hercules was a well-known emblem of Florence *and* of the Medici, but in the later 1530s Hercules—specifically Hercules with Antaeus—was identifiable with Alessandro and Cosimo as lords of Florence. If a date of 1537–38 could be established for Pontormo's portrait on secure grounds, then the image on the hat badge might seem to support a Medicean identification of the sitter. (I have suggested that even the writer of the 1612 inventory may have thought this.) But the problem is not so simple.

Pontormo did not follow either Pollaiuolo's or Domenico di Polo's examples. The tight interlocking of the bodies of the two men—with Antaeus's left leg wrapped around Hercules' right haunch, his head sinking back as his left arm presses vainly down, and his body incapable of arching away any more—directly recalls Michelangelo's more recent designs of 1524–25 for a *Hercules and Antaeus*, in which he set out to capture the pathos of the ancient *Laocoön* group.[93] Michelangelo's commission from the Florentine republic to carve a marble Hercules to stand beside his *David* outside the Palazzo della Signoria goes back to 1508. It was always threatened by

the rivalry between the republic and the Medici popes for Michelangelo's services, and both Leo x and Clement vii determined to impose Baccio Bandinelli in his place. Their plan succeeded after the fall of the republic in 1530. However, this was only after Michelangelo had made several designs, the most significant of which for us are those he made at the request of the Signoria in 1525.

In one small drawing [FIGURE 31] Michelangelo explored the potential for uniting two serpentine forms in a spiraling movement within a closed block, and in a manner quite different from the exploding, open contours of Pollaiuolo's group. Charles de Tolnay described Michelangelo's configuration as "an expression of the eternally struggling life force itself," in which the figures become a transcendent unity.[94]

Small in scale, Pontormo's image demonstrates his deep understanding of Michelangelo's even smaller designs for a colossal group. As a result it has been suggested that Pontormo also adopted the ideology of Michelangelo's *Hercules and Antaeus*.

Figure 31
Michelangelo Buonarroti. *Studies for a Hercules and Antaeus Group* (detail of a sheet of miscellaneous drawings), circa 1524–25. Red chalk. Oxford, Ashmolean Museum, The University of Oxford.

71

But just what that ideology might be depends upon, rather than determines, the identification of the sitter. For those who believe that this is Cosimo I in 1537 the hat badge is one more example of the duke's appropriation of the imagery of the republic and of his ancestors in his forging of a new regime. If the *Halberdier* is instead a defender of the republic and painted at the time of the siege, then the Michelangelesque design, it has been argued, must have been intended to call to mind both the form and the function of the sculptural group commissioned by the republic in the teeth of opposition from the Medici pope. But is Pontormo's reference to a brilliantly conceived work of art, or to a political position, or possibly to something else altogether?

The most famous testimony about the fashion for wearing badges or medallions in hats comes from the sculptor Benvenuto Cellini, who describes how to make them in his *Treatise on Goldsmithing*.[95] He singles out a hat badge he had fashioned for one Girolamo Maretta from Siena, which showed Hercules and the Nemean Lion in such high relief that they were barely attached to the ground. So remarkable was this medal that Michelangelo proclaimed that "if this work were made on a large scale, whether of marble or of bronze, and fashioned with as exquisite design as this, it would astonish the world."[96] Inspired by these words, the sculptor determined to do even better.

The chance to make an especially elaborate badge came in 1528. Federigo Ginori, "a very beautiful young man," had fallen in love with a princess in Naples. Having seen the Hercules medal, he asked Cellini to design another to commemorate his love. He had wanted Michelangelo himself to produce the work, and the sculptor agreed to make a drawing, though insisting that Cellini would not need it. Cellini's medal was made up of a gold figure of Atlas carrying the heavens in the form of a ball of crystal, affixed to a ground of lapis lazuli and surrounded by a gold border of fruits and foliage. To this Cellini added a motto provided by Ginori: *summam tulisse juvat* (he delights in carrying the heaviest burden).

Cellini's informative account undermines the claim that Pontormo's painted hat badge necessarily supports the identification of the *Halberdier* as Cosimo I in 1537–38. First of all, it indicates that hat brooches of extraordinary quality were very fashionable in the late 1520s, and that such quality was not reserved only for members of the Medici family. It records one occasion when even Michelangelo was asked to design such a small object, and for a private citizen during the republic. It alerts us to the fact that not every image of Hercules around 1530 is associable with the Medici. And lastly, it tells us

that the subject and motto in this case were chosen by the patron in reference to a personal and private sentiment, not a public or political one.[97]

When Pontormo painted his own virtuoso representation of struggling heroic nudes on a small scale, he did not slavishly follow Michelangelo. Like Cellini, he was capable of producing his own design and, as we have seen, he was also a brilliant reader of Michelangelo's work. A red-chalk drawing by Pontormo for a *Rape of the Sabines* of around 1520, made when he was deeply affected by Michelangelo's presence in Florence, shows the upper body of one of the marauding Romans to the right as almost identical with the upper body of Hercules in the hat badge—his right arm reaches across the figure he has seized, and his head looks out at the spectator [FIGURE 32]. Though not as frontally intertwined as the Hercules and Antaeus in Michelangelo's drawing, the two figures (indeed the whole composition) show how closely Pontormo had studied Michelangelo's lifelong exploitation of the force of evenly matched contrapposto and the effects of pathos. On the hat badge, with a few short dabs of the brush, Pontormo gave Antaeus the suffering visage of the *Laocoön*, a visage that was almost his obsession in the 1520s. At that moment Michelangelo's own conception of the struggling figures of *Hercules and Antaeus* was in turn related to the contorted rebellion of the figure of *Day* for the Medici Chapel—which, as Charles de Tolnay understood, represents sadness and pain rather than fury [see FIGURE 11, lower right]. Pontormo's design for the *Rape of the Sabines* (and the hat badge of the *Halberdier*) participates in this same pathos, which Michelangelo adapted both for a heroic image for the republic and for a Medici monument.

Following the lessons of Cellini's story, we may begin to see that the true relationship Pontormo's figures bear to the example of Michelangelo is one of shared expressive pathos, rather than one of merely fixing an ideological point of view. At the same time, we know that the devices shown on such badges had meanings, and in understanding that this particular emblem is not unique to Cosimo de' Medici, we need to consider other possible readings that might account for the adoption of this personal

Figure 32
Pontormo. *Study for the Rape of the Sabines* (detail), circa 1520. Red chalk, 17.3 × 28.5 cm (6¾ × 11¼ in.) (whole drawing). Florence, Galleria degli Uffizi (6672F). Photo: Canali Photobank, Italy.

ornament by Francesco Guardi. One explanation may be found in the writings of the famous Florentine political theorist Niccolò Machiavelli, who summons up the image of the mortal struggle between Hercules and Antaeus in a context that is significant for the siege. In his *Discourses on the First Decade of Livy* (composed in 1515–16), Machiavelli considers whether in cases of danger it is better to go out to fight or to wait at home for the enemy.[98] To various examples in favor of biding at home, he adds his own version of the fable of Antaeus, king of Libya, who was insuperable on his own ground, that is, for as long as he stayed inside his kingdom. When taken from his own ground by the strength and craft of Hercules, he lost both his state and his life. "And so," writes Machiavelli, "has grown up the fable that Antaeus replenished his strength from his mother, who was the Earth, as long as he was on the ground; and that Hercules, seeing this, picked him up and distanced him from it." The moral is that one is on stronger ground defending one's home. Machiavelli saw a profound difference, however, between armed states such as ancient Rome, and unarmed ones such as those in modern Italy, which had to do everything possible to keep the enemy far away.

Machiavelli held the employment of mercenaries in contempt. In *The Prince* he describes such troops as "divided, ambitious, undisciplined, unfaithful, brave among friends and cowardly among enemies, without fear of God and without faith in men." They fight only for *un poco di stipendio* (small wages), and this is not enough to make them want to die in the interests of others.[99] Italy's ruin was the result of dependence on mercenaries, and Machiavelli provides a mnemonic image for this moral. When David volunteered to fight Goliath, Saul offered him his own armor to give him courage. But after trying on the armor, David rejected it, saying that thus armed he could not make use of his own worth, and that he preferred to seek out the enemy with only his sling and his knife.[100]

This *figura,* as Machiavelli called it, from the Old Testament was especially appropriate for his native Florence, which had adopted both David and Hercules as figures of the city's virtue. He argued vigorously, and for a time successfully during Soderini's leadership of the republic, for the creation of citizen militias on the ancient model. In 1527, after having served both the republic and the Medici, Machiavelli hoped that he might regain his position in charge of the militia. But this was not to be. Scant days after his return he died, despised by all parties. Though inspired by Machiavellian rhetoric, the militias were to be reconstituted by the republic in a quite different way.[101]

Machiavelli's conclusion that a well-armed state will defend itself through its own virtue by standing its own ground provides a subtle alternative to the more sharply drawn political readings (often based on extrinsic evidence) that have been made of Pontormo's portrait. The *figura* of Hercules and Antaeus, like that of David and Goliath, would have been highly appropriate for a young Florentine to wear in his hat at the time of the siege. As David slew Goliath with his own weapons and through his own virtue, so the greater strength of Hercules succeeded in defeating the powerful Antaeus only by luring him away from home. The moral could work both ways, however. Once armed, the Florentines could not easily be defeated if, like Antaeus, they fought at home. The siege by imperial forces between October 1529 and August 1530 severely tested Florentine optimism. Hercules was also a figure adopted by Charles v (whose device showed the Pillars of Hercules), and the lifting of Antaeus by Hercules could easily be understood as a figure for siege, the difficult struggle to pluck a determined defender off his home ground.

In Pontormo's struggling figures, as in Michelangelo's drawing for the statue commissioned by the republic, the unresolved tension expresses a sustained torment, pathos, and complexity, almost as if within a single body. Accordingly, the youth's hat badge of *Hercules and Antaeus* cannot be read as an unambiguously partisan image. Civil war does not work that way, and the devices displayed on hat badges, normally highly individualized forms of ornament rather than political statements, rarely work that way either. Although the *concetto* of this hat badge is not recorded, Pontormo's ingenious and witty antithesis between the overpowering and cruel Antaeus, lifted off the ground by the wily and strong Hercules, and this virtuous young man who stands guard at a bastion, armed and ready to hold his ground on his native soil, is just the sort of conceit such ornaments were intended to convey. Francesco Guardi, as one of the *bella gioventù* gallantly guarding the walls of his native city, might quite appropriately have owned such a badge with the emblem of Hercules, who in any event had been associated with the freedom of the city for at least two centuries. Extraordinary in Pontormo's compositional use of it is the juxtaposition of pathos and youthful beauty, where struggling fear contrasts with perennial hope.

PORTRAITS AND PURPOSES · Portraits of private citizens in the Renaissance were generally made for specific reasons, often related to such events as reaching manhood, marriage, the birth of a child, or widowhood. Raphael's famous portraits of

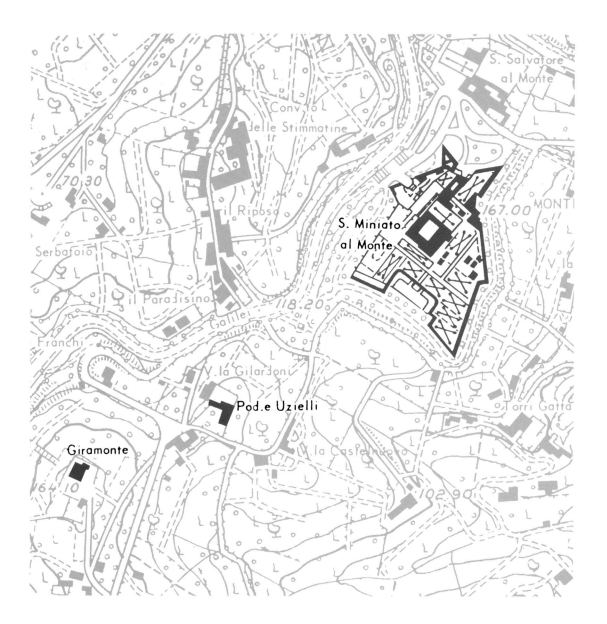

Figure 33

Modern contour map of Florence showing Guardi property (now called "Uzielli") between Giramonte and Monte San Miniato.

Agnolo and Maddalena Doni record their marriage, and the chiaroscuro images of Deucalion and Pirrha on their backs refer to the hope for the generation of heirs.[102] The painting of *Mona Lisa*, probably the most famous Florentine portrait of all, has been associated with the del Giocondos' move into new quarters, signaling their establishment of their own household.[103]

The resolution of all the Guardi del Monte family's property disputes, in one of the last private settlements to be made before the pressures of war forced the suspension of private hearings, was just such an occasion. As we have seen, it was the existence of Giovanni Guardi's young male heir, Francesco, that made the settlement so happy and promising.

Far less happy was the fortune of the Guardi property at San Miniato — the farm and house known as "La Piazzuola." Had Francesco da San Gallo's fortification plan for Clement VIII been realized, La Piazzuola would have been included within the defensive walls, together with Giramonte. When the line of defense was pulled back to San Miniato, however, the Guardi farm was left exposed, lying exactly between the cannons of Alessandro Vitelli and the guns of the republic at San Miniato [FIGURE 33]. This was the property Giovanni Guardi had inherited from his father, and which, after the hearing of August 1529, he anticipated leaving with all the rest of his possessions to his son and heir Francesco. That the Guardi property was cut off from the city at the very point where real artillery battle daily took place [see FIGURE 17] adds to the portrait's intensity of meaning, and helps to explain why this young man should be standing before a defensive wall. In a very particular sense, the line drawn between San Miniato and Giramonte at the beginning of the siege in October 1529 divided the Guardis from their property. The same line also divided Florentines from each other and made the predicament of the Guardi del Monte emblematic of the sufferings and divisions that affected the entire city.

Other Guardi properties within the city and adjacent to the Porta alla Croce, the Tre Canti, and the Porta a Pinti were also at risk, and the risk along the wall could only add to the force of showing the Guardi's young heir standing in their defense.[104] In the last analysis, however, the stark angle of bare green that Pontormo depicted must represent the great earthworks erected at Monte San Miniato, the keystone of the defense of Florence. We have seen how important these were as the point of constant military engagement during the siege. In 1616 Matteo Rosselli represented just this angle in model form in his painting of Michelangelo presenting the design of the bastion at San

Figure 34
Matteo Rosselli (Italian, 1578–1651). *Michelangelo Directing the Building of the Bastions at San Miniato*, 1615–16. Oil on canvas, 236 × 141 cm (92⅞ × 55½ in.). Florence, Casa Buonarroti. Photo: Canali Photobank, Italy.

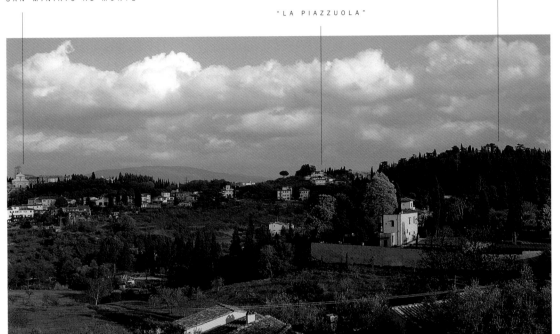

Figure 35
Landscape at San
Miniato showing the
site of the Guardi
property. Photo:
Nicolò Orsi Battaglini.

Miniato [FIGURE 34]. Michelangelo had thrown everything into building the defenses there, and Pontormo did not have to be one of Michelangelo's closest admirers—which he was—to understand its importance. Michelangelo moved into the Santa Croce neighborhood after the expulsion of the Medici in 1527, but, again, one did not have to be Michelangelo's neighbor to know that he was working day and night to defend Monte San Miniato. We have seen that all the greenery of the suburbs was thrown into building these earthen walls in October 1529. We can thus understand why Pontormo would have represented young Francesco Guardi against the background of this green bastion (and quite clearly not, as the supporters of the Cosimo thesis maintain, before the distinctive stone bosses of the Fortezza da Basso later built by Alessandro de' Medici).[105] As he stands his ground, facing the enemy, he also looks across his own property, from which he was now divided by the forces of civil war [FIGURE 35].

That this young man's face, bearing, and fortune should have elicited such an extrordinary portrait now begins to be more comprehensible. In the representation of Francesco Guardi, the young man who gained his inheritance in 1529 only to be

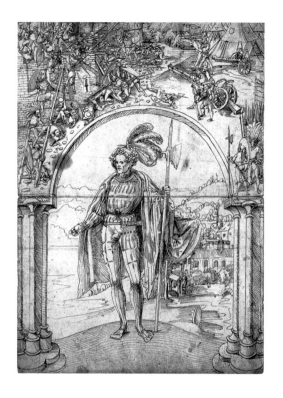

divided from it within two months, might be incorporated all the tensions, ambiguities, and even hopes of the defense of Florence against itself.

Conventionally, whether in mythological, religious, or historical scenes, in art as in life, the halberdier is a figure who stands guard, and who, as a result, can even stand for whole military forces. In 1507, for example, Niklaus Manuel had combined a young halberdier with a siege scene for a stained-glass window design [FIGURE 36]. We have already noted the halberdiers who keep watch inside the wall in Mielich's *Encampment of Charles V at Ingolstadt* [see FIGURE 15]. If this young man is Francesco Guardi, then not only his father's consolidation of his inheritance at the time of the siege, and the specific location of some of the family property, but his *very name itself* helped to determine the way Pontormo fashioned his image. Francesco Guardi, descendant of the thirteenth-century Guardus and sole heir of the Guardi del Monte (whose coat of arms bears the golden *monti* that signify his particular family), stands here as the *guardia del monte*. He is the vigilant militiaman posted as sentry (*guardia*) at the bastion of San Miniato al Monte. In Italian, *il fa la guardia* (he keeps watch) before the angle of the bastion set against the hill (*monte*) of the ancient monastery that was the highest point in the defense of Florence. He looks out from the Monte San Miniato at the enemy occupying his own land—a literal embodiment of the *guardia del Monte* established by the Signoria in the face of an overwhelming hostile force.[106] Francesco Guardi also looks directly at us, returning our gaze (*sguardo*).

That Guardi's own name so aptly fits the action, or image, of this portrait, fulfilling Renaissance expectations that portents could be found in names (*nomen omen*), provides powerful support for the identification of Francesco Guardi as the subject of the portrait. The practice of introducing such puns in portraits was popular in the early sixteenth century. In Lorenzo Lotto's portrait of Lucina Brembate, for example, a verbal hieroglyph is easily deciphered. In the sky appears the moon (*luna*) with the word *ci* inscribed in it, standing for *lu-ci-na*, or, Lucina's first name. In a more purely visual way

Leonardo da Vinci identified Ginevra de' Benci by including branches of juniper (*gine-pro*) both within the portrait and on its reverse [FIGURES 37, 38].[107] Pontormo pushed emblematic meaning to the limit in his portrait of Francesco Guardi by identifying the whole image with the sitter's name, and the sitter's outlook with that of Florence. Word play was second nature to Florentines, and those who called Pope Clement VII *Papa chi mente* would have had no difficulty in recognizing this portrait of a young *guardia del Monte* as Francesco Guardi del Monte, or, conversely, in seeing a portrait of Francesco Guardi del Monte looking out at the enemy that had deprived him of his property as a representation of the *vigilanti e gagliarde guardie* (as the Venetian emissary had called them) who were now guarding the city.

"... *WHICH WAS A MOST BEAUTIFUL WORK.* ..."

If this portrait represents Francesco Guardi at the time of the siege, what sort of portrait is it? I have suggested that the image is onomastic (based on the name of the sitter), commemorative (recording the Guardi family's consolidation of its estates), and emblematic (because this property was threatened in ways that could stand for the general threat to Florence). But does it also represent an actual historical situation in the sense imagined by Luciano Berti—a young man bravely standing guard at night while

the soldiers slept? To begin with some facts. Francesco Guardi would have celebrated his fifteenth birthday on 29 April 1529, and when the siege began he was fifteen and a half. In accordance with the initial experiment that had established a militia in 1528, all men and youths between the ages of fifteen and fifty were to be enrolled. However, only citizens from eighteen to thirty-six were actually sworn to arms. When Pontormo painted his portrait sometime in 1529–30, Francesco Guardi would have been on the threshold of service but not yet an armed member of the militia and so could only anticipate the glory of standing as guardian on the Monte San Miniato. In consequence Pontormo portrayed him as embodying the ardent hopes, the very idea of patriotic youth itself. It was such an idea of *bella gioventù*, incorporated in similarly beautiful and brave adolescent youths, that Jacopo Nardi also had in mind when he wrote of members of the militia taking their fifteen- or sixteen-year-old sons (and such indeed was Francesco Guardi) to military parades and to watch skirmishes outside the gates.[108] It was the image of such young men that the gonfaloniere Carducci had in mind when he urged Malatesta Baglione and Colonna to fight to the death rather than surrender. Could they tolerate, he begged them, seeing the city destroyed, its nuns violated, its chaste maidens put to shame, married women raped, widows corrupted, and, in his worst imaginings that made him weep in horror, "our young men raped and murdered simultaneously."[109]

Internal evidence helps with this implied date. The hat badge and the gold chain worn by the *Halberdier* are exactly what a young man of Guardi's wealthy class coveted as personal ornaments. They are also mentioned in a decision made by the Signoria in June 1530, when money ran short in the late days of the siege, that all worked or unworked gold, with very few exceptions, should be turned in. Hat badges, however, regularly worn by members of the militia, were specifically excluded from the legislation.[110] Gold chains were to be sacrificed. It is doubtful that such a piece of worked gold would have been included if the portrait was conceived after June 1530. The perfection of Pontormo's youthful figure, furthermore, stands in such contrast to the suffering bodies he depicted in the *Martyrdom of the Ten Thousand* that a date at the beginning of the conflict, late in 1529, seems most probable for the execution of the work.

The gold chain already appears in a preparatory drawing in the Uffizi [FIGURE 39], which provides a precious glimpse into the development of the portrait.[111] Two trial sketches appear; to the right Pontormo drew a narrow-waisted figure, almost nude (his bare torso is indicated even though he is wearing a collar), grasping the pommel of a sword with his left hand. His left ear stands out, and the right profile of the face

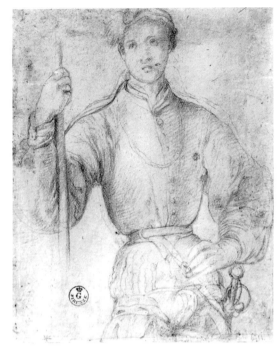

is strongly delineated; the left side of the neck slopes in an exaggerated way to a shoulder that is higher than its mate. This tension of head, neck, and shoulders, which invokes in the most subtle way Michelangelo's Giuliano de' Medici figure in the Medici Chapel [see FIGURE 11], also appears in the drawing on the left of the sheet, as it does in the finished portrait. The study on the left is squared; like its mate, and like the *Halberdier*, it is deliberately cut off just below the groin. The ear still stands out, with prominence given to the curve of the right cheek, and now the chain and sword belt are drawn in (though the navel is still visible). Quite different from the final portrait is the direction of the eyes, which here glance away to the side, lending the sitter an apprehensive air. Out of this image of a nervous young man wearing a chain and armed with a sword, Pontormo created a portrait of a young man *en face*, his right arm supporting a pole arm, his left hand on his hip above the pommel of his sword.[112]

That there is some connection between the Getty portrait and another study in the Uffizi, this time in red chalk [FIGURE 40], is beyond dispute.[113] Many of the details correspond to the final work. The left hand rests on the hip, the right holds the wood of a pole arm; the young man wears essentially the same costume and chain, a

Figure 39
Pontormo. *Portrait Studies*, circa 1529–30. Black chalk, 25.3 × 20.4 cm (10 × 8 in.). Florence, Galleria degli Uffizi (463Fv).

Figure 40
Pontormo. *Study of the Halberdier*, circa 1529–30. Red chalk, 20.9 × 16.9 cm (8¼ × 6⅝ in.). Florence, Galleria degli Uffizi (6701Fr).

hat with badge and feather, and a sword belt. But there is a sort of willowy wistfulness to the pose, turned toward our right, that the leftward and upward gaze of the eyes only enhances. The Uffizi drawing has long been considered preparatory for the portrait, in which case we must assume that Pontormo made a radical change at this point. But might not this highly finished and less-than-searching drawing be a reinterpretation, rather than an early idea? [114]

Other portraits by Pontormo meet the gaze of the beholder directly, but none does so with the bodily assertiveness of Francesco Guardi. We have some sense of just why *this* young man should have come to stand for watchfulness and for the flower of youth at the beginning of the siege. But how did Pontormo arrive at this image? An association with the Giuliano figure in the Medici Chapel has been proposed. In Florence in 1529, however, that figure was not yet the touchstone for stylish beauty that it was to become. Perhaps more appealing in the circumstances of the siege was the work of an artist who had flourished in the days of the old republic, and whom both Michelangelo and Pontormo admired: that is to say, Donatello.

Two sculptures by Donatello are called to mind by Pontormo's portrait. The first is the *Saint George* [FIGURE 41], completed for Or San Michele around 1416. This heroically youthful figure provided Pontormo with ideas for his first drawing [see FIGURE 39]. He turned the slender torso with its distinctive navel above the belt more to the left, and he reversed the straight and bent arms, picking up on the implication that the curved index finger and thumb of Donatello's statue held a sword. The head too is turned in the opposite direction, but Pontormo captured the nervous, sideways and upward glance of the sculpture. All the particulars of Pontormo's portrait are quite different, but the emphasis on the details of costume matches what we see in Donatello's approach to the costume of Saint George. The sword worn by Pontormo's young man is one of the most precisely portrayed rapiers in contemporary painting. [115] Like the hat badge, it bespeaks fine workmanship, standing, as we have seen, in stark contrast to the coarse bare wood of the pole arm. The simple leather belt and side-pieces from which this elegant sword hangs would have been produced by the guild of strapmakers, or *correggiai*, to which Guardi's ancestors belonged. [116]

More important for Pontormo's image than any detail was the bold stance and the quality of youthful watchfulness expressed by Donatello's *Saint George*, which was singled out in the sixteenth century precisely on account of its youthful beauty.

Vasari wrote in 1550 that "in the head one recognizes the beauty of youth, spirit and valor in arms, a proud and terrible liveliness, and a marvelous sense of movement within the stone."[117]

One of Pontormo's earliest known drawings is after Donatello's bronze *David*. For his frescoes for the Certosa at Galluzzo Pontormo studied Donatello's pulpits in San Lorenzo. In a drawing for the lunette at Poggio a Caiano he wittily adapted

Figure 41
Donatello (Donato de Betto di Bardi) (Italian, circa 1386–1466). *Saint George*, 1415–17. Marble, H: 209 cm (82 ¼ in.). Florence, Museo Nazionale del Bargello. Photo: Canali Photobank, Italy.

Figure 42

Donatello. *David* (detail
of head), 1412–16.
Marble, H (overall):
191 cm (75⅛ in.). Flor-
ence, Museo Nazionale
del Bargello. Photo:
Canali Photobank, Italy.

Figure 43

Pontormo. *Portrait of
a Halberdier*. Detail
of head.

the pairs of terra-cotta putti who cling to each other above Donatello's *Annunciation* in Santa Croce. The *Annunciation* was itself an important source for Pontormo's own version of the subject in the Capponi Chapel. Now the *Saint George* provided Pontormo with an image of beautiful youth, full of spirit and valor in arms, at the very moment when valor was called for, and when a young man on the verge of becoming one of the *bella gioventù* became his subject.

 Donatello's *Saint George* provided an idea. In the end it did not provide an expression, or mood, for Pontormo abandoned the nervous gaze of the first drawing in favor of a youthful perfection unmarked by experience, whether hope or fear. For that Pontormo drew upon another standing, frontal statue of a young man by Donatello. This was the marble *David*, installed in the Palazzo della Signoria in 1416. Again, what Donatello provided was not details, but an idea for a figure in whom youthful beauty and the fearlessness of that beauty were combined. A close comparison of the head of *David* with that of the *Halberdier* is instructive [FIGURES 42, 43]. The oval head sits on the neck in the same way, with strong emphasis on the exposed contour of the right cheek; the delicate nose is separated from the mouth by the same crisp furrow, the eyebrows are finely arched, and the brow perfectly unlined. Pontormo opened the lips a

little, and made them fleshier, in a youthful version of Michelangelo's divinely beautiful figures in the Sistine Chapel. The *Halberdier* becomes credible as a young man defending his Florentine heritage through a deliberately established ancestry in the youthful heroes of Donatello.

At the same time, the portrait of Francesco Guardi remains a private commission: it is a portrait of an individual, however ideally presented, and Pontormo's conception probably began with a drawing from life. But as swiftly as the circumstances of Florence and the Guardi family changed, the portrait was transformed into an image with a broader, more poignant significance. By means of its conspicuous association with Donatello, the portrait identified the specific person and character of Francesco Guardi, his promise and his conflicting hope and fears, with the character and emotions of Florence as the city struggled to define its own identity and mount its own defense. What started out as a celebratory portrait of the Guardi del Monte's heir soon after the property settlement in August of 1529, became in Pontormo's hand a portrait of the promise of Florentine youth "at the time of the siege."

IDEALS OF BEAUTY AND BEAUTIFUL MANNERS • By identifying Pontormo's portrait both with an artistic idea of youthful beauty, represented by Donatello, and with the name of a sitter, Francesco Guardi, we return to the issue raised by Vasari's claim that it really did not matter who such paintings actually represented, but only that they were by Pontormo. Of course it mattered very much who made the *Saint George* and the *David*, but Donatello's contemporaries would not have discounted the meaning of these figures in favor of seeing them purely as works of art. To be sure, this was partly because these sculptures were made for public display. But the critical climate in Florence had also changed, in ways art historians have associated with the stylistic tendency known as the *maniera*.

In the most general terms, it is has been argued that the younger generation of painters, which included Pontormo and Rosso Fiorentino, sought out new forms of expression by analyzing recent artistic developments (especially as represented by Leonardo and Michelangelo), together with art from northern Europe (in particular the prints of Albrecht Dürer and Lucas von Leyden), and rejecting the practice of combining natural observation with the study of ancient sculpture, which had been the paradigm of High Renaissance art in Rome.

The innovations of this radical generation, to summarize the general view a bit further, were codified and used repetitively by those who followed, whose work became genuinely mannered, that is to say, overly stylized and referring overtly to the traditions of art. Among the most influential interpretive keys to understanding the first *maniera* of such artists as Rosso and Pontormo has been the idea that their art prizes form—especially artistic or beautiful form—over content, reversing the "normal" relationship between the two.[118] Yet, what might have constituted "content" as opposed to "form" for a painter working in the 1520s and 1530s is not obvious.

Florence had changed greatly between the generations of Donatello and Pontormo, while striving always to appear the same. The struggles over Medicean ambition as pressed by Leo x and Clement VII were those of a society that remained mercantile in its own imagination, even while the Medicis, like the rulers of Ferrara, Mantua, Paris, or Rome, sought the creation of a court. Courtliness brought new codes of behavior, according to which urbanity, elegance, irony, and dissimulation were useful skills, to be cultivated along with the arts of writing, drawing and painting, horseback riding, and so on. We have seen how the political conflicts of the early sixteenth century were heightened by the appearance of weapons of war more brutal than any known before. This involved Florentines in the wider European conflict over the character of war itself. On the one side, war was violent, unprincipled, and the province of mercenaries. On the other, it was still governed in the imagination by codes of honor, a site for trials of *virtù*, for heroic action and glory.[119]

Pontormo's contemporary Ludovico Alamanni sought to turn citizens into courtiers by taking away their everyday mercantile clothes. Jacopo Nardi described how families now armed their young men for war, whereas when he was a boy, parents confiscated arms from their children.[120] However different their aims, the assumption of both, as of all sixteenth-century writers on manners, is that social ideals can be shaped, and that people can be fashioned or refashioned in a new image by altering their behavior and their dress. In sensing the contradictory messages present in the *Halberdier*, we do not respond only to the artist's skillful expression of the uncertainties of adolescent youth, comparable to those captured by Donatello in his *David*. Pontormo also brilliantly communicates to us that the identity of this youth at the time of the siege was itself being fashioned by a new culture of appearances. It was not simply inherited or natural. The *Halberdier*'s beauty (which associates him with the new militia of the *bella*

gioventù) and his relation to the Florentine tradition of Donatello (which endows him with historic valor in addition to his beauty) have as much to do with establishing that this is Francesco Guardi as do the details of the hat badge and bastion.

THE IMAGE OF PERFECT BEAUTY · The beauty of Francesco Guardi resembles that of several other figures in Pontormo's work around 1530. Most obvious is its connection with the youthful figures in the Capponi *Deposition*, and especially with the young woman to the left in the Carmignano *Visitation* [see FIGURES 7, 21]. These resemblances are not merely an aspect of chronological proximity but result from the way in which Pontormo envisioned the portrait. The close relationship of this young man to figures in Pontormo's contemporary religious works is an important clue to the divine purpose of the youth's cause and the significance of his beauty. Florence in 1530 was dedicated to Christ; as the Savonarolan faction especially believed, Florentines were the chosen people.

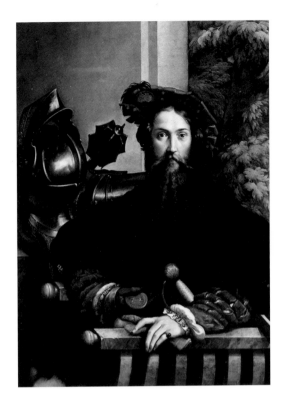

Figure 44
Parmigianino (Francesco Mazzuoli) (Italian, 1503–1540). *Portrait of Galeazzo Sanvitale*, 1524. Oil on panel, 109 × 81 cm (42⅞ × 31⅞ in.). Naples, Museo e Gallerie Nazionali di Capodimonte. Photo: Canali Photobank, Italy.

Arms and beauty are held in a similarly poignant, even provocative balance in Parmigianino's portrait of Count Galeazzo Sanvitale of Fontanellato [FIGURE 44]. The count long maintained his loyalty to the French in the peninsular wars, and the portrait was painted in 1524 just before the Battle of Pavia (1525), after which he and his family had to flee to Parma in defeat. The numbers 7 and 2 on the medal held by the count are a sign for the name of God according to the so-called Christian cabala, which was of much interest in Savonarolan circles at the time. As if reflected in a mirror, Sanvitale's *en face* portrait provides an image of self-knowledge and a recognition of the self as a reflection of God's beauty, made in God's image. This recognition on Parmigianino's part was grounded both in the Christian cabala and in his own experiments with self-imaging in a mirror, without which the frontal stare of the sitter could not have been conceived.[121] All the objects in Parmigianino's portrait also appear as

clearly as reflections, as if the whole portrait itself is a mirror. These vividly depicted trappings of war—armor, helmet, and mace—leave no doubt that, his beautiful god-like appearance notwithstanding, Sanvitale's true profession is war. His very beauty, however, promises peace.

Pontormo almost certainly never saw the Sanvitale portrait, but he shared Parmigianino's interest in mirrors, and the two artists may even have met in Florence on Parmigianino's journey to Rome soon after the portrait was finished. Pontormo's face looks out from within the Capponi *Deposition*, and a drawing in the British Museum of circa 1525 [see FRONTISPIECE] has long been identified as a self-portrait, showing the artist drawing as he points to himself in a mirror.[122] In the *Halberdier* the angle of the bastion serves to thrust the bodily presence of the figure forward rather than setting it in space, enhancing the sense produced by the directness of the sitter's gaze that we are seeing an image reflected in the surface of a mirror.[123] The frontal clarity of Guardi's gaze (his *sguardo*) signifies the beauty of the image in the mirror, and, by extension, identifies it with the reflection of the divine image in man, or, conversely, with the idea of man himself as a reflection of God. As in Parmigianino's portrait, the details of Guardi's weapons point to the worldly work of war, and the beauty of the figure to the ultimate victory of peace. In Florence in 1529–30, a city governed more by religious fervor than by political will, the identification of the sacrifice of the *bella gioventù* with an *imitatio Christi* was almost inevitable. This was a holy war.

Other contemporary artists also portrayed young warriors, and just one or two comparisons point up the originality of Pontormo's invention. Bronzino's portrait of the eighteen-year-old Guidobaldo della Rovere [FIGURE 45] is a case in point. Bronzino, who left Florence for the court of Urbino in Pesaro as soon as the siege was over, completed it in 1532. The portrait is usually, and with some justification, compared in a general way to works by Titian, and the importance of Dosso Dossi for Bronzino at this moment should also be recognized.[124] But it is the *Halberdier*'s head and shoulders that are closely replicated here. The three-quarters format, the way the head is set on the shoulders, the center line of the chest, even the detailing of the belt and sword, the simplicity of the green curtained background, and, above all, the direct gaze, all confirm that Bronzino had his teacher's most recent portrait in mind. In the end, however, Bronzino's purpose—and his sitter's—was quite different. Born in the same year as Francesco Guardi, and so just two years older at the time of this portrait,

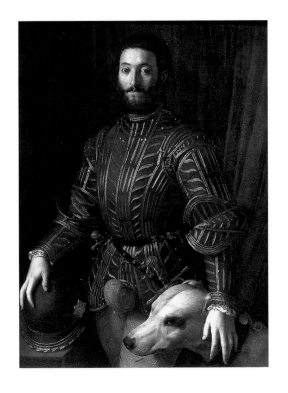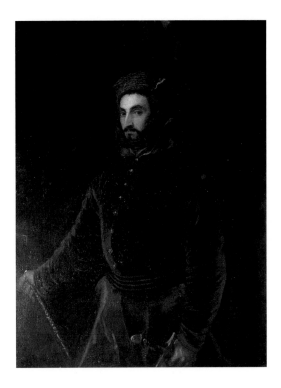

Guidobaldo has a full beard, emphasizing his virile maturity.[125] His valor is signified by his magnificent Milanese armor; his peaceful, even amorous, pursuit of hunting by his dog; and his literary culture by the Greek inscription on the emblem on his helmet. His image conforms to Castiglione's wish for the combination of arms and letters, and his portrayal has none of the provocative simplicity of the youthful *Halberdier*.

Different again is Titian's *Portrait of Ippolito de' Medici*, painted in Bologna in 1533 [FIGURE 46]. The twenty-two-year-old son of Giuliano, duke of Nemours, boasts of his participation in the Hungarian campaign against the Turks by choosing to be represented in a Hungarian plum-colored velvet costume. Even war could bring a courtier knowledge of the world, its customs and costumes, though Castiglione complained about those who donned fancy or foreign dress.[126] The beardless young Francesco Guardi, as we have seen, wears nothing foreign to himself.

Figure 45
Bronzino. *Portrait of Guidobaldo della Rovere*, 1532. Oil on panel, 114 × 86 cm (44⅞ × 33⅞ in.). Florence, Galleria Palatina, Palazzo Pitti (149). Photo: Canali Photobank, Italy.

Figure 46
Titian (Tiziano Vecellio) (Italian, circa 1488–1576). *Portrait of Ippolito de' Medici*, 1533. Oil on canvas, 139 × 107 cm (54¾ × 42⅛ in.). Florence, Galleria Palatina, Palazzo Pitti. Photo: Canali Photobank, Italy.

The practice of providing portraits with painted covers became fashionable in sixteenth-century Europe.[127] The custom was closely related to the convention of painting allegorical or heraldic images on the reverse of portraits, which in its turn derives from the design of ancient medals. One of the best-known examples of this is Leonardo da Vinci's portrait of Ginevra de' Benci [see FIGURES 37, 38], in which Ginevra's beauty on the front is commented upon by the emblematic image on the reverse. Following the traditions of Petrarchan poetry, this emblem, in which sprigs of laurel and juniper are bound together by a ribbon bearing the inscription *Virtutem forma decorat* (her beauty adorns virtue), establishes her absence and her immortality. In other examples mythological scenes carry more specifically amorous association, possibly standing for expectations of fidelity and chastity in marriage.[128]

Where emblematic, heraldic, or mythological images were produced as covers for portraits, rather than as reverses, the two parts have rarely survived together, and their connection is practically impossible to reconstruct. Without Vasari's mention of Bronzino's *Pygmalion and Galatea* [FIGURE 47] as the cover for Pontormo's portrait of Francesco Guardi, the mythological scene would probably have been taken as an independent work of art. If we agree that the *Halberdier* is indeed the portrait in question, then this becomes one of the exceptionally rare instances in which an Italian portrait can be linked with its cover.[129]

It has often been argued that the *Pygmalion and Galatea* could not have been the cover of the *Halberdier* because it is smaller than the portrait. In very few cases, however, do we know how such covers were mounted. Sometimes portraits and covers were hinged together in the form of a book, rather like devotional diptychs on which the beholder could meditate. Other portrait covers were made to slide across the portrait, just like the cover of a mirror. Remarkably like such a mirror cover in both form and imagery is a panel in the Uffizi [FIGURE 48] decorated with grotesques and a mask and bearing the motto *SVA CVIQVE PERSONA* (to each his own role, or, persona). The panel has lost its original frame, but it probably covered a portrait of a woman.[130] Acknowledging the power of self-fashioning in the mirror of the portrait, the pro-

Figure 47
Bronzino. *Pygmalion and Galatea*, circa 1530–32. Oil on panel, 81 × 63 cm (31 7/8 × 25 1/4 in.). Florence, Galleria degli Uffizi (1890 no. 9933). Photo: Canali Photobank, Italy.

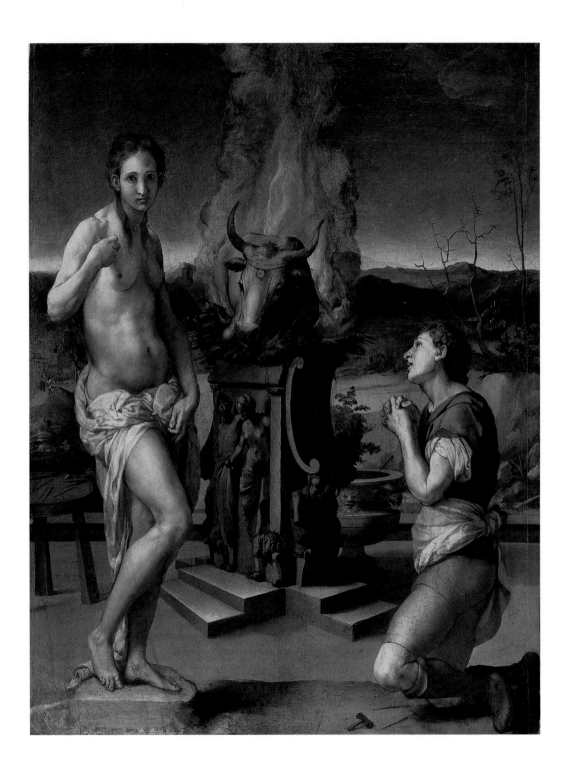

Figure 48
Attributed to Girolamo
Bugiardini (Italian, 1475–
1554). *Sua Cuique
Persona*. Oil on panel,
73 × 50.3 cm (28¾ ×
19¾ in.). Florence,
Galleria degli Uffizi (1890
no. 6042). Photo:
Canali Photobank, Italy.

Figure 49
Albrecht Dürer (German,
1471–1528). *Portrait of
Hieronymus Holzschuher*
(with cover), 1526. Oil
on panel, 51 × 37 cm
(20⅛ × 14⅝ in.).
Berlin, Staatliche Museen
zu Berlin—Preußischer
Kulturbesitz, Gemälde-
galerie (557E). Photo:
Jörg P. Anders.

verbial motto implies its completion on the part of artist and beholder in the words
MIHI MEA (to me my own). Another example of this type, unique because all the frames
are original, is Dürer's portrait of Hieronymus Holzschuher, dated 1526 and now in
Berlin [FIGURE 49]. In this case the cover is indeed larger than the portrait.

Even though the present dimensions of Bronzino's *Pygmalion and Galatea*
are certainly not original, the panel is larger than even the outer frame of Dürer's
Holzschuher portrait. The *Pygmalion and Galatea* is, quite simply, larger than other
such covers we know. The portrait it covered must also have been large, on the scale of
the *Halberdier*, making it hard to imagine that Bronzino's painting could have func-
tioned as a sliding cover. No matter how the two panels were attached, however, a frame
around the cover could easily have filled the evenly proportioned difference in size
between it and the portrait.

By 1644 Bronzino's *Pygmalion and Galatea* had already been separated from
Pontormo's portrait of Francesco Guardi and was in the Barberini collection in Rome.
It is important for the identification of the Getty portrait proposed here that the prove-
nance of Bronzino's panel presents no new difficulties. The Guardi family became extinct
in the seventeenth century (though both cover and portrait were likely sold out of the
family even earlier). The Barberini, originally neighbors of the Guardi at Santa Croce,

Figure 50

Pontormo. *Study for Saint Francis*, for the altarpiece in the church of San Michele Visdomini, 1518. Black chalk, 36.7 × 25.3 cm (14½ × 10 in.). Florence, Galleria degli Uffizi (6744Fr).

had easy access to Florentine pictures. It also makes sense that it was the cover that left Florence, for Pontormo's works were more closely protected than those of his pupil.

Bronzino's invention owes a good deal to the example of his teacher. The kneeling figure of Pygmalion derives from a nude study [FIGURE 50] for the praying figure of Saint Francis in Pontormo's much earlier Visdomini altarpiece, dated 1518.[131] In another borrowing, Bronzino also based the legs of Galatea on the drawing for the legs of Saint Michael, one of the two panels Pontormo made for the church of San Michele at Pontorme soon, according to Vasari, after the Visdomini altar.[132] These connections with Pontormo's drawings suggest that Bronzino made this work before departing for Pesaro at the end of the siege, in August of 1530, or, less likely, after his return in 1532. Nothing in this part of the story, then, contradicts the argument that the *Halberdier* is the portrait of Francesco Guardi painted by Pontormo at the time of the siege, and for which, according to Vasari, Bronzino made the *Pygmalion and Galatea* as a cover.

Francesco di Giovanni Guardi's daughter, Diamante, was born only in 1538, his son Giovanni in 1539, followed by another son, Neri. It is unlikely that Francesco's marriage to Selvaggia Cambini could have taken place before the mid-1530s, which in turn makes it implausible that, as has been proposed for several other surviving reverses or covers showing mythological scenes, this important event is celebrated here.[133] Can

the two images be related in some other way? I have suggested that Francesco Guardi is shown as a young guard looking out from the earthworks of San Miniato at the embattled territory that included part of his own inheritance. In Bronzino's cover the altar on which the sacrifice is made stands on a parapet overlooking a blasted landscape, punctuated by dead or dying trees. In the distance the sun rises behind the hills, and to the left is a small church with a well, near which a handful of people struggle along. This bare landscape, its few trees blasted by powder, as they are in Schön's *Siege of Münster* [see FIGURE 16], and the familiar hills on the horizon clearly define the surroundings of Florence devastated by the siege.[134] In those hills was the Guardi's farm, La Piazzuola, from which Francesco and his family were separated by war.

The altar in Bronzino's painting is dedicated to Venus, according to the story of Pygmalion as told by Ovid (*Metamorphoses* 10.238–297). In Ovid's tale, Pygmalion was so disgusted by women who denied the divinity of Venus that he remained celibate. With marvelous art he carved out of ivory a woman more beautiful than any in nature. So perfectly did his art conceal his art (*ars adeo latet arte sua*) that the sculpture seemed real, and Pygmalion conceived a passionate desire for her. On the feast of Venus, therefore, when heifers "with spreading horn covered in gold" were sacrificed to Venus on altars smoking with incense, Pygmalion prayed that the goddess would send him a virgin "like his ivory one." He dared not, says Ovid, ask for the statue itself to come alive, only for its likeness. Venus made the flames burn brightly and leap into the air, and when Pygmalion returned home he kissed and caressed his statue until the ivory became flesh in his hands, and the maiden came alive.

In the sixteenth and seventeenth centuries the story of Pygmalion was inseparable from the theme of artistic virtuosity and of competition among the arts. Pontormo himself, in his response of 1547 to Benedetto Varchi's inquiry about the relative merits of painting and sculpture, wrote that the important thing was to surpass nature by giving life to a figure, to make it seem alive, and to do that on a plane surface; even though when God made man he worked in relief because it was easier to make him seem alive that way.[135] Varchi, defending the superiority of sculpture, countered with the argument that Pygmalion's statue and other ancient "idols" were in relief so as to deceive the beholder more perfectly. Varchi did, however, acknowledge that the *Venus* in Bartolomeo Bettini's house, drawn by Michelangelo and colored by Pontormo at the end of the siege, equaled the *Venus* of Praxiteles in its power to arouse physical desire.

Although this formal, theoretical comparison of the arts did not take place until the 1540s, there is every reason to suppose that Bronzino was commenting on the consummate liveliness and ideal perfection of Pontormo's *Halberdier* when he conceived his *Pygmalion and Galatea* as its cover. The theme of the artist sacrificing to Venus (or, Beauty), who has pacified Mars (or, War), heightens that connection. Art flourishes when Venus triumphs over Mars, and, by providing this comment to Pontormo's image of a young soldier, Bronzino glossed the conspicuous virtuosity of that painting. By so doing, he emphasized the exquisite beauty of Pontormo's portrayal of Guardi's perfect youth, drawing attention away from specific references to the defense of Florence. Like Pygmalion, Bronzino concealed his art with art itself. In the charged political climate of Florence in 1530–32 such concealment may have been prudent.[136]

Venus is shown embraced by Mars in the fictive relief on Bronzino's altar, but this is not described by Ovid. In the famous opening invocation to Lucretius's *De rerum natura*, however, the poet prays for Venus to vanquish Mars so that Rome may enjoy peace and the arts may flourish. Bronzino's inclusion of Mars on the altar of Venus thus signals that Pygmalion's sacrifice is also offered for the conclusion of war— he prays not only to Venus but also for peace. But there is a deep irony in Bronzino's invention, for Venus is shown clasping the apple of discord, and it was Paris's awarding of this apple to Venus in recognition of her supreme beauty that led to the Trojan War. The altar raised by Pygmalion bears the dedication *HEV VI VENVS* (*heu vincit Venus*, or, Alas, Venus won), which oddly combines the forms of Roman epigraphic inscriptions and lyric poetry, as the word "alas" signals. The witty paradox of dedicating an altar to Venus both as the cause of war and as the goddess of peace suggests that the source of war also lies in love and the desire for beauty.

The wit of Bronzino's invention is reinforced by the plaintive expressions on the faces of the rams on the altar and by the bowed heads of the fragmentary figures supporting the cartouche. On a more somber level, however, it could indeed be said that the siege itself arose from the love felt by both contending factions for Florence and from the desire of each to possess the city with its legendary arts and beauty. Hence Bronzino's paradoxical invocation of Venus in the *Pygmalion and Galatea* suggests additional comment upon Pontormo's portrait of the young man dressed as a soldier that it once covered—one that may be characterized as eristic. Paris had given Venus the apple of the cruel goddess Eris, or, Strife, who makes war and battle thrive. But in antiquity

Eris was not an only child. A second Eris was given by Zeus to help men, and it is through her urging to rivalry that artists and poets are led to virtuous competition. The inscription on the altar and the apple of discord in Venus's hand underscore the vivid contrast between the devastation of the landscape by war and the production of the beauty of Galatea by love and art. At the same time Bronzino's conceit of Venus's conquest of Mars on the altar inverts the image of Hercules and Antaeus on Francesco Guardi's hat badge quite specifically. Venus's beauty indicates the cause and effects of the arts of peace, which now supersede the tragic struggles of siege and civil war. The substitution of rivalry in artistic perfection for political factionalism was to become the center of Cosimo I's cultural policy of rebirth. Such virtuous rivalry is already enacted in Bronzino's emulation of his master, Pontormo, by painting the *Pygmalion and Galatea* as the emblematic cover for the portrait of Francesco Guardi. And Pontormo's fashioning of Guardi as a work of art, the perfect image of all the Florentine *bella gioventù* prepared to sacrifice themselves at the altar of war, is reciprocated in Bronzino's image of the work of art made alive in the present and in peace.

AFTERWORD

Francesco Guardi died on 6 September 1554, some time after his second wife. Like others of his generation, he had reconciled with the regime, fulfilling his duties as a Florentine citizen. In 1548 he was elected a captain of his confraternity, the Congregatione di Santa Maria della Croce del Tempio (called the Compagnia dei Neri), which provided succor to convicted criminals as they were about to be executed.[137] In 1550 he served as a member of the Two Hundred. Francesco asked to be buried with his ancestors and, because his oldest son, Giovanni, was only fifteen, tried to make his younger brother, Gherardo, the guardian of his three children.[138] Gherardo refused the responsibility.[139] As a result, Francesco's children became wards of the office of the *Pupilli* (orphans' court). The accounts of the court record sales of grain on their behalf, arrangements to have them learn music and to have Giovanni and Neri attend grammar school.[140] In the four years after Francesco's death there were frequent outlays for maintaining all his properties, which now included a house in the Via Larga that the children had inherited from their mother's family, the Cambini. In December of 1559 it was decided that Francesco's daughter, Diamante, should marry Giuliano di Ugo Ciofi.[141]

Francesco's son Giovanni seems to have left no heirs.[142] His other son, Neri—"il Capitano"—served in the cavalry guard of Duke Cosimo and also appears to have died without heirs. His wild career provides a strong clue to the possible fate of his father's portrait. In 1574 Neri was convicted in absentia of illegal gambling, given a huge fine of 4,000 scudi, sentenced to four lashes of the whip, and exiled to Elba for three years. If he refused to present himself to the authorities in two months' time, he was to be sent to the galleys. He had also secured the murder of Filippo Barducci, whose loaded dice had brought about the original dispute. After confessing, Neri di Francesco Guardi was hanged on 18 April 1577.[143] He had brought Francesco's line of the family to ruin, and many items must have been sold to pay off his debts.

The Guardi del Monte family continued through the line of Francesco's brother Gherardo, who produced three sons, Orazio, Francesco, and Scipione, and a daughter, Margherita. Francesco di Gherardo would marry Caterina di Vieri de' Medici

and bring forth five sons and a daughter, Livia. Antonio Maria, son of Paolo di Francesco di Attilio, would inherit Il Palagietto and the property at La Mattonaia in 1658, but he too seems to have produced no heirs.[144] Livia, daughter of Francesco di Gherardo (and our Francesco's great-niece) received the property at San Miniato as her dowry when she married Ludovico di Vincenzo Teri in 1615.[145]

At some point in the steady dispersal of all the properties assembled with such care in the early part of the sixteenth century the alienation of the portrait of the young heir, Francesco Guardi, who represented the family's greatest hope at the moment of Florence's greatest peril, must have occurred. Though there could have been many reasons for Gherardo's refusal to take care of his brother's children in 1554, financial difficulties present the clearest motive. It is easy to imagine how the identity of the *Halberdier* could have become lost between Francesco Guardi's death in 1554, Vasari's account of 1568 (which gives no location for the portrait), Neri's execution in 1577, and the Riccardi inventory of 1612.

EFFECTS • Pontormo's portrait of Francesco Guardi had an immediate effect on the portraiture of Bronzino, evident in both the younger artist's portrait of Guidobaldo della Rovere of 1531–32 [see FIGURE 45] and his *Portrait of a Young Man with a Book* in the Metropolitan Museum [FIGURE 51]. Craig Hugh Smyth observed already in 1955 that the *Halberdier* and the *Young Man with a Book* are the same size (by which he meant the dimensions of the figures themselves, not just the supports).[146] The Metropolitan portrait is not documented, but the evidence of X-radiographs indicates that it was extensively reworked by Bronzino. Originally both the figure and the simpler angles of the architecture in the *Young Man with a Book* were even closer to the *Halberdier*. Smyth argued that the first, "more Pontormesque" version was begun before Bronzino left for Pesaro at the end of the siege in 1530, and that it was reworked while he was there.[147]

Also extremely close in format and figural contours to the *Halberdier* is a portrait in the Piasecka Johnson Collection that has been associated with another entry in the Riccardi inventory identifying a portrait of Cosimo I [FIGURE 52]. In 1948, before Keutner's discovery of the inventory, Berenson attributed this work (then *senza casa*) to Pontormo, though he did not identify the sitter. Keutner identified the portrait described in this entry with a different work.[148] It was only in 1962 that Robert Simon argued that the portrait should be associated with the entry in the inventory, which reads as follows:

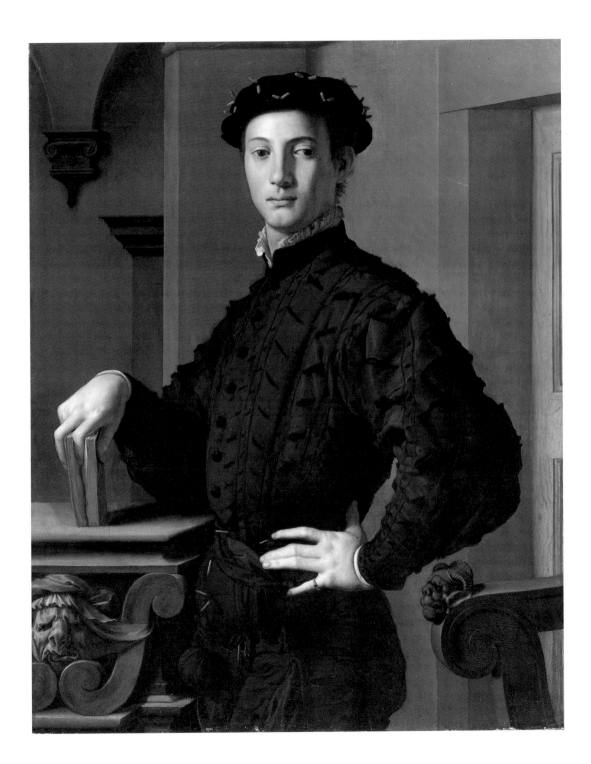

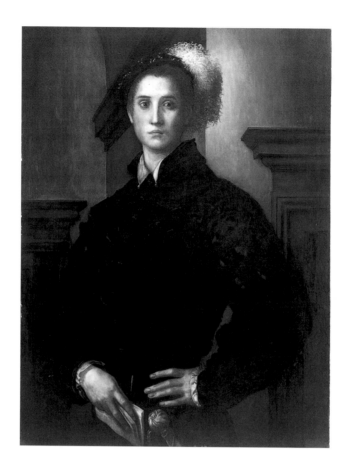

A portrait like the others in the other lunettes, thought to be by Jacopo da Pontormo, with a beret on his head, white feather, a sword at his side, and dressed in a plain black garment [*saio*], of the Most Excellent Duke Cosimo, with a frame.[149]

On the basis of a newly discovered resemblance between the two sitters, Simon thought that both the *Halberdier* and the Piasecka Johnson picture (then at Wildenstein's) were portraits of Cosimo and that this was confirmed by the inventory. He claimed that the Piasecka Johnson portrait *is* the painting described in the 1612 document but did not accept its attribution to Pontormo. In 1989, on the other hand, Janet Cox-Rearick accepted both the identification of this portrait with the inventory entry and its attribution to Pontormo.[150] Philippe Costamagna came to the same conclusion, claiming, as we have seen, that the portrait must have belonged to Ottaviano de' Medici.[151]

The identification of this second sitter is important to defenders of the hypothesis that the *Halberdier* portrays Cosimo I. Proving that the Piasecka Johnson and Getty portraits represent the same person, and that they are those described in the inventory, would help the cases for the former as being by Pontormo and for both as being portraits of the duke as a young man. Moreover, so the argument goes, a portrait of Cosimo I is more likely to have prompted imitations and other versions than is a portrait of an unknown Florentine. Costamagna, especially, has sought to reinforce an association of the Piasecka Johnson portrait with the *Halberdier* by fantasizing that the former was sent to Naples in 1538–39 to show Eleonora of Toledo the likeness of the man she was to marry. Understanding the importance of the correspondence between the scale and contours of the sitters in both portraits, he suggested that Pontormo reused the cartoon from the earlier *Halberdier* because there was no time to produce anything new. He added that the Piasecka Johnson picture was "certainly [!] exhibited in the rooms of the palace of the viceroy of Naples" at the time of Eleonora's marriage by proxy to Cosimo I. Finally, embroidering on an already fictional account, he concluded the painting was brought back to Florence in Eleonora's baggage.

Only Luciano Berti looked critically at this mounting house of cards.[152] His pointing out that after 1537 Cosimo had a beard was ignored on the grounds that Cosimo's beard was so wispy he would have preferred his bride not see it even hinted at! More difficult to ignore was Berti's observation that the Riccardi inventory makes no mention of the book held by the young man in the Piasecka Johnson portrait. Costamagna responded that in Riccardi inventories of 1810 and 1814 a book *is* mentioned (although the attribution to Pontormo and the identification as Cosimo disappear). However, the collection inventoried in 1810 and 1814 was no longer that of Riccardo Riccardi. The *Halberdier* had already been sold to LeBrun, and other paintings had been added. If this *is* the picture described in 1612, which remains only a likelihood, the very similarity of the poses of the sitters in the two portraits, regardless of their actual facial resemblance, might have led the writer to call the second a portrait of Cosimo, once he had identified the *Halberdier* as representing the duke. Yet the similarity between the two sitters is, to say the least, open to question.

Any discussion of the Piasecka Johnson painting must begin by acknowledging its ruinous condition: the face in particular is not to be trusted.[153] However, its format and especially its innovative low viewpoint and architectural setting indicate Pontormo's authorship. As in the *Halberdier*, the figure is not set into space but against

103

an angle that runs parallel to the side of his head and disappears behind his shoulder. Here the youth's arms are flanked by two doors framed by *pietra serena*, one set into a wall in the right foreground and the other set into a wall in the left background. As also occurs in Pontormo's Certosa frescoes and his Carmignano *Visitation*, space is defined through sudden juxtapositions: the lintel of the foreground door is at the level of the youth's jaw; that of the door in the rear is at the level of his shoulder. The foreground wall turns back at a right angle just to the right of the youth's head, forming the base for the springing of an arched vault and indicates the space of a courtyard beyond.

This spatial arrangement is in fact very close to the one designed by Bronzino for his early version of the *Portrait of a Young Man with a Book*, as revealed by X-radiography [FIGURE 53]. Examination of both the *Halberdier* and the Piasecka Johnson portrait confirms Costamagna's intuition that some kind of compositional drawing or cartoon was involved as a starting point in working out similar poses of virtually identical dimensions, which were then subtly adjusted as the actual painting progressed. But the closeness of the original version of Bronzino's *Young Man with a Book* to Pontormo's *Halberdier*, as Smyth noticed long ago, complicates the problem. For instead of two portraits, one of which Costamagna hypothesizes was produced in a hurry for a wedding, we now have three. Moreover, to that group of three, I think we have to add a fourth—Bronzino's portrait of Guidobaldo della Rovere [see FIGURE 45]. Furthermore, the problem becomes more complex once other portraits by Bronzino from the 1530s are taken into account.[154]

In this short book we cannot examine the complex chronology of Bronzino's portraiture. The relationship Pontormo's *Halberdier* and the Piasecka Johnson portrait bear to the portraiture of Pontormo's pupil Bronzino is, however, so important for the dating of our portrait and for the identification of its sitter, that we cannot ignore this question altogether: the influence of the Getty portrait as a portrait of Cosimo was the final claim made in the 1989 sales catalogue.

As a portrait of Cosimo I the *Halberdier* could not date earlier than 1537–38. When Cox-Rearick pointed to the decisive influence of this painting on Florentine portraiture, she cited the Piasecka Johnson picture and the *Portrait of a Young Man with a Book*, dating both versions of the latter to 1540–45.[155] But even if this late date (especially for the original version) be accepted, the consequent implications for the relationship between Pontormo and his pupil are problematic. Moreover, the production of the *Halberdier* as a vivid portrait of Cosimo I cast as a youthful soldier clad in bright

Figure 53
X-radiograph showing the
first version of Bronzino's
Young Man with a Book
(figure 51). Courtesy
Paintings Conservation
Department, The Metro-
politan Museum of Art,
New York.

colors just when Bronzino was painting men dressed in the somber black hues favored at the Medici court—the *Portrait of Ugolino Martelli* and the *Man with a Lute*, for example—becomes all the more inexplicable. And if we take into account the close connection Smyth initially saw between the *Halberdier* and Bronzino's portrait of Guidobaldo della Rovere—certainly datable between April of 1531 and April of 1532—then we would have to explain why in 1537 Pontormo would have reverted to a design by his pupil for a portrait he probably never saw.

If the *Halberdier* and the Piasecka Johnson portrait are both returned to circa 1529–30, however, then a more logical sequence can be plotted. Once the invention of the latter is recognized as being by Pontormo and its connection to the *Halberdier* understood, then the derivation of the first version of Bronzino's *Portrait of a Young Man with a Book* (wherever it was begun) from the model of Pontormo may be seen as the starting point for the portraits by Bronzino that follow. Here, as in the

Piasecka Johnson painting, a cornice runs behind the head, and the architecture is marked by two simple angles and a door. The portrait of Guidobaldo della Rovere [see FIGURE 45], certainly painted in Pesaro, probably followed soon after. When Bronzino returned to Medicean Florence in 1532, he undertook an intense restudy of Michelangelo's works in the Medici Chapel, resulting in a distancing of his portraiture from the manner of Pontormo.[156]

In connection with Bronzino's remarkable series of portraits from the late 1530s and 1540s, I once suggested that it was as difficult to *be* a Florentine in these decades as to represent one.[157] In Bronzino's portraits sitters are identified as Florentines through the close similarity they bear to artistic ideas expressed in Michelangelo's Giuliano de' Medici, recently installed in the Medici Chapel in San Lorenzo. Their Florentine identity is reinforced by architectural settings that incorporate creative references to Michelangelo's architecture and its Tuscan, especially Brunelleschian sources [see FIGURE 11]. In the case of Bronzino's portrait of Ugolino Martelli [FIGURE 54] a statue of *David*, owned by the Martelli and at that time thought to be by Donatello, is depicted and functions as another Florentine attribute. While Pontormo had conceived Francesco Guardi as the contemporary embodiment of a Donatello *David*, Bronzino's sitter counts such a figure among his cultural possessions, together with his palace and the copies of Bembo, Virgil, and Homer that he displays before him. Martelli's own person is fashioned after the graceful figure of a Medici sculptured by Michelangelo.

Bronzino's close analysis of the Medici Chapel sculptures and architecture paralleled systematic investigations of style in other aspects of culture. Duke Alessandro and Duke Cosimo both promoted writing in the Tuscan vernacular, and Cosimo especially asserted the traditions of Florentine *disegno* as the foundation for a rebirth of art. It was in the new court's interest to emphasize continuity with the Florentine past, whether that meant the early republic of Cosimo il Vecchio, or the more recent traditions of Michelangelo, Andrea del Sarto, and Pontormo. In this way the reality of empire could be disguised.

In Bronzino's portraits of the 1530s and 1540s young men dressed in black present themselves as figures of civil culture; they appear to live peacefully in urban palaces, surrounded by works of art. In the case of the Martelli portrait, war—and ancient war at that—is something to read about rather than to fight: Ugolino's hand rests on an open copy of the *Iliad*. Only with great difficulty can we imagine the gallant young Francesco Guardi as portrayed by Pontormo within this postsiege world.

Figure 54
Bronzino. *Portrait of Ugolino Martelli*, circa 1539. Oil on panel, 102 × 85 cm (40⅛ × 33½ in.). Berlin, Staatliche Museen zu Berlin— Preußischer Kulturbesitz, Gemäldegalerie (338A). Photo: Jörg P. Anders.

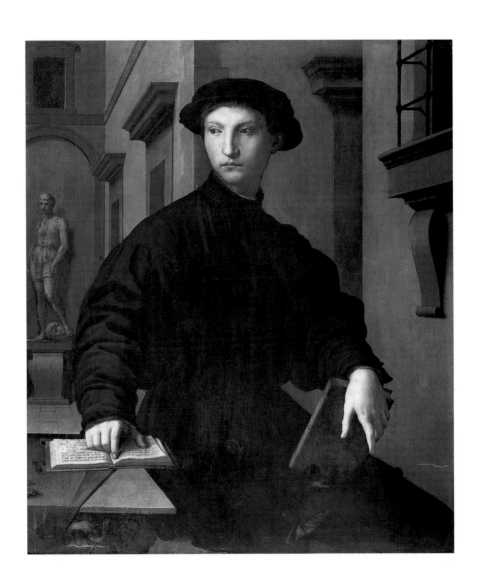

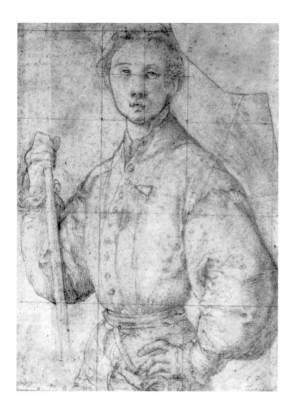

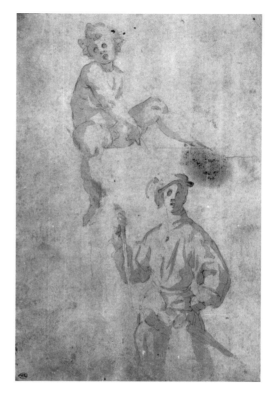

There is in fact little evidence that any artist other than Bronzino knew the portrait of Francesco Guardi directly. Vasari gives no indication of ever having seen it; his comment that it was very beautiful was probably inspired by Bronzino. Important in this connection is a problematic drawing close to the Guardi portrait and squared for transfer [FIGURE 55], which Philip Pouncey attributed to Bronzino.[158] To date, only one other possible drawing after the *Halberdier* has come to light, in a sketchbook that once belonged to Baldinucci and is now in the Louvre [FIGURE 56]. This sheet also includes a study of a figure resembling one of the children in the lunette at Poggio a Caiano, though it does not correspond exactly to any of those in the fresco or in known drawings by Pontormo. The drawing said to be after the *Halberdier* corresponds to its model even less closely; the figure has a much jauntier appearance, more like a costumed participant at a festival.[159] Whoever drew the sheet was probably working from drawings by the artist rather than the frescoes at Poggio a Caiano or the *Halberdier* directly. The portrait was not engraved before its purchase by LeBrun.[160]

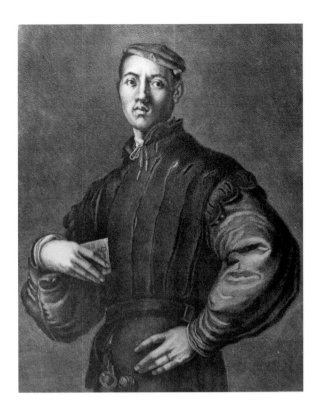

A lost portrait, known only through the engraving by Violante Vanni after a drawing by Lorenzo Lorenzi and made for the publication of the Gerini collection in 1759 [FIGURE 57], does bear some relationship to the *Halberdier*. The inscription indicates that this portrait was close in size to the Getty portrait, and attributes it to Allori. So different is the personality of the sitter—his nose and mouth rendered more coarsely, his expression quite troubled—that one can understand why the original was identified in 1825 as a portrait of the seventeenth-century Neapolitan revolutionary Masaniello. Among Neri di Francesco Guardi's gambling crowd was one Galeazzo Gerini, and it is tempting to imagine that the Gerinis knew the Guardi portrait, commissioning something similar from one of Bronzino's pupils. Quite amazing is the recent identification of the sitter as "clearly the young duke [Cosimo]."[161]

To insist that the Getty portrait is not the portrait of Francesco Guardi described by Vasari would mean that we have to presume lost a beautiful portrait of a young man,

Figure 57
Violante Vanni (Italian, circa 1732–1776), after a drawing by Lorenzo Lorenzi. *Portrait of a Young Man.* Engraving of a (lost) portrait attributed to Alessandro Allori. *Raccolta di ottanta Stampe rappresentanti i Quadri più scelte de' Signori Marchesi Gerini* (Florence, 1759), plate 28.

dressed as a soldier, painted by Pontormo at the time of the siege. And to ignore the problems of likeness, costume, symbolic meaning, political reality, chronology, and artistic influence that we have examined here would seem to require an unconditional admiration for the rule of the Medici that, in Berti's words, "does not help criticism."[162] Against the argument that as late as 1537 Cosimo de' Medici would have asked Pontormo to portray him as a member of the *bella gioventù* who had defended Florentine liberty against the Medici, and that Pontormo then employed every means at his disposal to make him appear so, there is really no answer. Might not this young man, the argument would go, skilled in the courtly art of dissimulation, have avoided overt references to his own personal imagery, even his identity, in this portrait if it stems from the first year of rule? And might he not have preferred to present himself in the guise of a young Florentine of a certain rank, defending his city, and in a manner that was in keeping with portrayals of his republican ancestors? In other words, whoever this young man is, the fact that there could be any confusion over his identity might indeed result from the policies of Cosimo himself, and the politics of 1537–38. Duke Alessandro and Duke Cosimo both cultivated Florentine cultural autonomy in the face of the power of the emperor; through such devices as the figure of Hercules they sought to tie together the republican past and the imperial present of their family.[163]

In 1537, however, Cosimo I de' Medici needed above all to look manly, not youthful. His courtiers were to be men of culture, his bodyguards and soldiers just that. Pontormo's exquisitely calibrated portrait of Francesco Guardi at the time of the siege provides in the figure of one young man—a new David who was as yet too young to fight, and whose very existence, from his beautiful face to his conspicuous codpiece, promised the continuity of his family genealogy—the most poignant and provocative memory of a civil war that divided Florence from its past and determined the course of its future. The struggle between Hercules and Antaeus around the walls of Florence had ended without heroic victory, and without the intervention of angels. The days of the *bella gioventù* were over.

NOTES

For abbreviated references, please see the bibliography.

1 The Christie's sale catalogue *An Important Painting by Pontormo* provided a summary history of the painting and a discussion of its critical fortune. Though unsigned, this essay was written by Janet Cox-Rearick. It is cited below as [Cox-Rearick], 1989.

2 Berti, 1990, p. 47.

3 The painting was cleaned in the mid-1970s by Gabriella Kopelman, who detected a slight split at the top from the time of the transfer. She also found some traces of water-based tempera in the feather. The medium is otherwise oil.

4 Mather, p. 66.

5 Keutner, pp. 146–150, 152.

6 Postcard to Melvin Ross, 30 March 1941, Walters Art Gallery file.

7 Keutner, p. 152. ASF, Carte Riccardi 258, fols. 21r and 21v. The Florentine *braccia* was approximately 58.36 cm. This would make the portrait 73 cm high, rather than 92 cm.

8 Keutner, p. 151. ASF, Carte Riccardi 258, fol. 21r. This would make the Walters portrait 87 cm high, which is correct. Though precise measurements should not be expected in inventories, it is worth noting that in 1612 the Getty portrait was identified as somewhat smaller than that in the Walters, rather than vice versa.

9 See further Berti, 1990, pp. 44–45.

10 Freedberg, 1990, pp. 688–689 n. 20, made this same observation, remaining skeptical about the lack of resemblance to Cosimo. He had earlier dismissed the Cosimo identification as "certainly erroneous" (1971, p. 484 n. 20), and later accepted the likelihood of Cox-Rearick's argument only with great reluctance.

11 Vasari-Milanesi, 6, p. 275. For a highly abbreviated version of the argument that follows, see Cropper, in Florence, 1996, nos. 140–141, pp. 376–379.

12 Ibid., 6, p. 278. Neroni was born 26 December 1511; see AOD, Registro dei Battezzati, Maschi 1501–11, fol. 178. Amerigo was born 27 November 1516; ibid., fol. 88v. Like many wealthy Florentines, Amerigo's father, Camilo, was fined more than once and even imprisoned in the Palazzo Vecchio for refusing office and not paying taxes levied by the republic during the siege. On Amerigo, see *Archivi dell'aristocrazia fiorentina*, exh. cat. (Florence, Biblioteca Medicea Laurenziana, 1989), pp. 171–172, citing letters patent from Henry VII to raise two thousand soldiers for the king in 1545. In 1544 Antinori had raised troops for Cosimo I.

13 I am grateful to Muriel Vervat for pointing out that the dimensions of the *Pygmalion and Galatea* were increased to fit the current frame at the time of the exhibition *L'Opera ritrovata* in 1984. Neither the measurements of the cover, nor those of the portrait, may be relied on.

14 In *Masterpieces of Painting*, no. 8, David Jaffé rejects the identification of Cosimo on the grounds of lack of resemblance, suggesting the name of Francesco Guardi.

15 [Cox-Rearick], 1989, pp. 23–26.

16 Cox-Rearick, 1964, 1, pp. 269–271. Seeing no resemblance to Cosimo, she here describes the portrait as inseparable in style from the Santa Felicità phase.

17 Cox-Rearick, 1984, p. 254 n. 10, citing Malcolm Campbell's suggestion of this possibility, which, however intriguing, raises other

problems, especially in connection with the costume and the setting.

18 Vasari-Milanesi, 8, p. 187. Pinelli, p. 58, cites this to explain away the lack of resemblance, even while maintaining that the *Halberdier* resembles the Ghirlandaio portrait.

19 Archivio Bartolini Salimbeni, *Processi* no. 18, "Ricordi per il giardino particolarmente vendita di Gualfonda." See also ASF, Rondinelli Vitelli, filza 7, no. 25.

20 ASF, Carte Riccardi 258, fols. 5–6: "Statue, teste, e marmi nella casa, cortile, e Giardino di Gualfonda."

21 These were prized works. On 17 August 1673, Domenico Gori was paid to make seven gilded frames for the "disegni di chiaroscuro che sono di mano di Jacopo da Puntormo e di Andrea del Sarto" (ASF, Carte Riccardi 790, filza 15). See now Ciseri, in Florence, 1996, pp. 208–211, nos. 64–65.

22 ASF, Carte Riccardi 790, filza 1 (signed by Giorgio Vasari the Younger).

23 The sculptor Orazio Mocchi (circa 1550–1625) rented a house and a garden there, as well as a room in which he worked. Other nameless builders and carvers who rented houses were probably employed in maintaining the grand property, with its walled gardens, labyrinth, allées of trees, and sculptures. Riccardo's heirs continued this tradition, and in 1627 a house was rented to Lorenzo Cerrini (1590–1659), a pupil of Allori's. Another was rented by the famous court singer Francesca Caccini (1587–circa 1640). Francesca was the daughter of Giulio Caccini (known as Giulio Romano), who wrote music for Peri's *Euridice* and the *Rapimento di Cefalo*, both of which were performed at the marriage celebrations of Maria de' Medici in 1600. A close friend of Michelangelo Buonarroti the Younger, Caccini was also the niece of Giovan Battista Caccini, who restored ancient sculptures in the Medici collection. ASF, Carte Riccardi 258, fols. 1v–2r, and 259, fol. 34v.

24 Costamagna, pp. 244, 296–297. The evidence for this is entirely lacking. On Ottaviano, see D. R. Wright; Bracciante; Cox-Rearick, 1984.

25 Vasari-Milanesi, 6, p. 282.

26 Gamba already proposed this in 1910, for which see Cox-Rearick, 1964, 1, pp. 299–300. Rubinstein, p. 24 n. 30, makes the same point.

27 Roth, pp. 214, 224 n. 154, 251 n. 1. The story narrated below relies on Roth's thorough account, which is based on documents and published contemporary records. Further archival research has produced nothing to alter the salient facts. On the history of Florence in these years, see further Jones, Polizzotto, and Stephens.

28 On these numbers, see Roth, pp. 76, 184, 320, and references.

29 Roth, p. 299; *L'Assedio*, p. 210; Varchi, pp. 286–287, 289–290.

30 Varchi, p. 210.

31 Roth, p. 158.

32 Ibid., p. 139.

33 Gilbert, p. 252.

34 Stephens, pp. 181–182.

35 Roth, pp. 23–31; Stephens, pp. 198–202; Polizzotto, pp. 334–386. That 26 April was the anniversary of the assassination of Giuliano de' Medici in 1478 (as well as of the death of Simonetta Vespucci in 1476) may well have added to political tension.

36 Stephens, p. 234; see also Roth, p. 111.

37 Roth, pp. 190–191.

38 *L'Assedio*, p. 138.

39 Ibid., pp. 81–83.

40 Roth, p. 263.

41 *L'Assedio*, pp. 203–204 n. 1.

42 ASF, Arch. della Repubblica, Signori e Collegi, *Delib ord.* 133, p. 44v: "excepto solamente le medaglie da portar nelle berrette o medaglie antiche e li stuzzichati d'archibugi e gli smalti di bacini doctore."

43 *Libri dell'arte della guerra*, 7, in Machiavelli, p. 433.

44 Roth, p. 129 n. 12.

45 After taking the vote, the councillors are reported to have said, "God be thanked. Now we will be rid of this pack of children (*fanciullaia*)." Varchi, p. 131.

46 The chronology of the legislation is difficult to establish, as Varchi noted. See Roth, pp. 117–118, 130 n. 17; for the legislation of 1528, see Polidori; for later changes, see Roth, pp. 194–197, 298–299. See also Trexler, pp. 529–547; Bayley, pp. 292–315.

47 *L'Assedio*, pp. 148–149.

48 Stephens, p. 197.

49 Trexler, p. 534.

50 Trexler, pp. 535–537. See Landucci, p. 368, for the appearance on 5 February of "16 bandiere verde co' loro sengni di gonfaloni in Piazza, che erano fatte di nuovo pe' la sopradetta milizia." See also Lapini, p. 95.

51 According to Trexler, p. 530, "it was the miracle of disciplined youth, fighting without wages for their *patria* that would stand out against the failure of the *vecchi*."

52 Roth, p. 126.

53 Stephens, pp. 252–253.

54 Trexler, p. 545.

55 Clapp, p. 280, who gives the date of 1529 according to the old Florentine year, which began on March 25. For the purposes of our study all dates will be given according to the modern calendar. See Elam, 1994, for the development of the neighborhood of Piazza Santissima Annunziata.

56 Cellini, 1985, pp. 187–188.

57 Vasari-Milanesi, 5, p. 52. Florence, 1986, pp. 163–165, no. 28.

58 Florence, 1986, pp. 137–139, no. 20.

59 Roth, pp. 195–196, records the report that Sarto was a member, but provides no documentation other than his age.

60 Vasari-Milanesi, 6, pp. 262–263. See Elam, 1993, and Bartoli, in Florence, 1996, pp. 248–253, nos. 82–84, for further references.

61 Again, this portrait, unlike the *Halberdier*, can be documented in the Uffizi in 1603, and it was probably already in the Medici collection in 1587. See Costamagna, pp. 150–152, no. 33.

62 Roth, pp. 191–192; see also *L'Assedio*, p. 148.

63 For the chronology of these frescoes in relation to the Capponi Chapel, see Pilliod.

64 An indication of Pontormo's fears is provided in Vasari's report of how Pontormo later tried to excuse himself to his disappointed Medici patrons at Castello "by saying that he had never worked willingly in that place because, since it was away from the city, it seemed it would be exposed to the fury of the soldiers and other such dangers." Vasari-Milanesi, 6, p. 283.

65 Ibid., p. 273.

66 *Istorie fiorentine*, II. 35–37, in Machiavelli, pp. 538–544.

67 Wasserman; Costamagna, pp. 204–206, no. 62.

68 Costamagna, pp. 196–199, no. 59.

69 Recent attempts to date the Carmignano *Visitation* to 1538 remain inconclusive, despite the claims of Pinelli, pp. 57–58. Pinelli's case rests on Trenti Antonelli's claim that the endowment of the altar of the *Visitation* at Carmignano dates to 1538. In fact, Trenti Antonelli, pp. 31–49, documents only Bartolomea Pinadori's bequest of 18 lire to the convent of San Francesco in Carmignano for the celebration of the "festa della Visitazione al suo altare," on 25 June 1538. This finds confirmation in another record, generously shared with me by David Franklin in 1994 (ASF, Corp. soppr. sotto P. Leopoldo, 92, Santa Croce di Firenze, vol. 236, fol. 101r), also dated 25 June 1538, in which Bartolomea, widow of Piero Pinadori, leaves 14 lire a year for candles and various masses. Special masses are to be said in the convent on the feast of the Visitation at the altar of the *Visitation*, "intitulato l'altare de'

Pinadori." This suggests that the altar already existed, and in neither document is there any bequest for an altarpiece. It remains likely that Piero di Paolo Pinadori, who died in 1526, was the patron of the altar and that the altarpiece dates to the late 1520s.

70 Polizzotto, pp. 263–264. If the Pinadori in question were indeed anti-Medicean in 1537–38, then it is even more unlikely that Pontormo would, or could, have painted their altarpiece at the same moment he was painting Cosimo's portrait. Moreover, the manifest interest in Dürer's prints, always commented upon in connection with the *Visitation*, is an aspect of Pontormo's style in the 1520s; it does not seem to survive the siege. The chronological problems remain complex, but the identification of the portrait as Guardi, circa 1530, does not depend on an early date for the *Visitation*.

71 Costamagna, pp. 207–211, no. 65; Cropper, in Florence, 1996, pp. 382–383.

72 Vasari-Milanesi, 6, p. 275.

73 Polizzotto, pp. 381–382.

74 Costamagna, pp. 215–221, nos. 69 and 70.

75 Cited without reference by Berti, 1990, p. 49. I determined the same date in AOD, Registro dei Battezzati, Maschi 1512–22, fol. 39. Francesco's sister Nanna was born on 6 August 1515 (Femmine 1513–22, fol. 43v). For her dowry, see ASF, Monte delle Graticole, Part II, 3755, fol. 238. In ASF, Tratte 88, fol. 127v, Francesco's birthdate is given as 28 April 1514. He was approved "per Conservatores" in 1539. See further ASF, Cittadinario, S. Croce, filza 3, fol. 45v.

76 ASF, Manoscritti 250, Priorista Mariani, vol. 6, fol. 1402v. For the Guardi in Leone Nero, see vol. 3, fol. 746. For the habitation of members of the various branches in 1551–52 (when Francesco and Gherardo lived next to each other), see ASF, Miscellanea Medicea 223, fols. 85v, 86, 97, 98, 109v, 110. In that year Pontormo had Alessandra di Mariotti Guardi as a neighbor on Via Laura (fol. 162), and both

Battista del Tasso and Tribolo's widow lived down the street. BNF, Carte Strozziane, Ser. II, 129, fol. 176, provides a partial Guardi family tree, from Lapo to Francesco.

77 ASF, Manoscritti 393, Carte Dei, filza 27:2 (hereafter Carte Dei), p. 24. This printed *Ultimo sommario giustificazioni nella causa vertente tra il venerabile spedale di S. Maria degli'Innocenti da una e gli'illustrissimi signori fratelli, e figliuolo del . . . Buonsignore Spinelli e li Signori Ludovico e Ascanio Terri dall'altra* (Florence, 1725), refers to earlier documents, using old-style dating so far as I can tell. I have modernized these dates.

78 Giovanni calls his wife Diamante in his will of 1515 (Carte Dei, p. 24), where his first marriage, to Lucrezia, by whom he had a daughter, Maria, is also mentioned. Diamante's family name is given in ASF, Manoscritti 360, Carte dell'Ancisa MM, fol. 149v. For the 1515 will, see also ASF, Not. antecos. 4857, fol. 45v.

79 ASF, Decima Repubblicana 14, fols. 455–462. The palace was partly rented out in 1481.

80 Carte Dei, pp. 1–2.

81 For this and what follows, see Carte Dei, pp. 5–23.

82 The phrase *ad praesens Magnificus Vexillifer Justitiae Populi Florentini* identifies him clearly. Francesco di Girolamo Inghirlami was designated one of the administrators of the hospital of San Sebastiano by the Signoria in 1527.

83 Giovanni also made bequests to Santa Croce, for which see, e.g., ASF, Conv. Soppr., S. Croce, 303, filza 14. I have found no record of Gherardo's baptism, which may mean that he was born outside Florence.

84 See [Cox-Rearick], 1989, p. 16 ("not actually in soldier's dress"); pp. 26–28 ("dressed in deliberate and nostalgic emulation of the past"); the bright colors "those of past Republican times"; the costume "military" but not Florentine, the sort of "pseudo-military" costume Cosimo liked to wear; it "recalls the particular mode of military dress characteristic of the

Landsknechte," although "Cosimo's" hat indicates that he is not dressed "literally—down to the last detail—as a Landsknecht"; in sum he is "nostalgically dressed up as a soldier in imitation of Giovanni delle Bande Nere, perhaps even wearing items of clothing that had come down to him from his father." Giovanni delle Bande Nere was not a landsknecht. He was, however, killed by landsknechts, which could have given Cosimo I little reason to wear even a "modified" landsknecht costume. Even Simoncelli, p. 506, who supports the Cosimo identification, makes this point.

85 Rubinstein, p. 23. In his earliest medals the beardless Cosimo wears armor. Forster, 1971, aware of the difficulty, proposed that "Cosimo" carries a jousting lance. To reinforce the association Forster had made with the image of Camillus in Ghirlandaio's fresco in the Palazzo Vecchio, the illustration in the 1989 catalogue was cropped in such a way that the fluttering standard atop the tilting pole in Camillus's hand is not seen. As a result the similarity to the pole arm in the hand of the *Halberdier* was artificially enhanced.

86 Hare, p. 130. On 15 July 1523, Maria writes, "Have made for me a gold chain for Cosimo of 4 or 5 ducats, and a gold medal for Cosimo. You will have all this made as soon as you have any money; that is all." Later that year Clement VII sent the four-year-old Cosimo 20 ducats to buy a pony. Costamagna, p. 235, sought to identify the *Halberdier*'s chain as a gift from the pope, the mark of a chivalric order; but, as Simoncelli, p. 506, also points out, it bears none of the familiar emblems of such knighthoods. The ornament is just what any prominent young man might wear.

87 Berti, 1990, p. 45. [Cox-Rearick], 1989, p. 26, notes the same accounts of Cosimo's preference for somber dress, responding that his costume in the *Halberdier* reflects instead a nostalgic emulation of the past.

88 Berti, 1993, p. 154. The account also points to the new fashion for beards, but this would not apply to the fifteen-year-old Guardi.

89 Polidori, p. 403. The color of this costume might also be significant, although color symbolism is so rich that almost any hypothesis can be substantiated. The doublet is a creamy silk taffeta, shot with some pink, but it could be called silvery gold, or even white, which might be seen in connection with the red hose as the colors of Charles V. On the other hand, the *Halberdier*'s colors could just as well stand for the republic as for the imperial court. Red and white were the colors of Florentine virtue, the colors of the banners of the city and its people, as seen in the roundel in the Sant'Anna altarpiece. One version of the Guardi crest shows red borders, together with the gold mounts crossed with azure on an argent field.

90 Hackenbroch, p. 17.

91 On Hercules and Florence, see Ettlinger, and A. Wright.

92 Cox-Rearick, 1984, pp. 146–153, 253–254.

93 Cox-Rearick made this connection in 1964, 1, pp. 270–271. At that time she dated the *Halberdier* to circa 1527–28. In the 1989 catalogue, p. 35, however, she identified the painting as a portrait of Cosimo I dated to 1537–38 and consequently attempted to link the design of the hat badge to Pontormo's drawing of 1531–34 for Poggio a Caiano, concluding that with this connection "another aspect of the picture would be brought into relationship with the proposed date in the 1530s." This argument ignores the even closer connection to Pontormo's *Rape of the Sabines*, cited below, not to mention the established connection to Michelangelo. See Shearman, 1972, p. 210, for discussion of Cox-Rearick's earlier identification of motifs and connections between drawings and paintings.

94 De Tolnay, p. 103.

95 Cellini, 1967, p. 45; Hackenbroch, pp. 19–21.

96 Translation emended from Cellini, 1967, p. 48.

97 Nor did this *capriccio*, as Cellini called it, involve a reference to the owner's name. Cox-Rearick, 1964, 1, p. 171, proposed that the

figure of Hercules in Pontormo's portrait identifies the young man as one Count Ercole Rangone, who became a commander at the time of the siege. Simoncelli, p. 506 n. 73, points to the political impossibility of the Rangone argument, already abandoned by its author in 1989. See Berti, 1966, p. 57, for another suggestion that the emblem might identify this unknown young man as under the command of Ercole d'Este, who was the captain-general of the Florentines before 1529, but who never participated in the war. Berti changed his view once the young Guardi had been identified.

98 *Sopra la Prima Deca di Tito Livio*, 2:12, in Machiavelli, pp. 256–259.

99 *Il Principe*, 12, in Machiavelli, pp. 86–87.

100 *Il Principe*, 13, in Machiavelli, p. 91.

101 See Bayley, pp. 240–293, for the militias; pp. 268–284, for their disgrace after the failure to hold Prato in 1512.

102 Hayum.

103 Zöllner, esp. pp. 122–123.

104 A key point in Michelangelo's fortification lay between the Porta alla Croce and the Porta a Pinti. Here was an angle with a tower known as the "Tre Canti." In 1840, in his historical romance about the siege, Ademollo describes how the palace of the Guardi outside this angle was not destroyed because it was enclosed by the bastion Michelangelo constructed there (4, pp. 1374–1375). In his notes to the novel, Luigi Passerini identifies the Guardi del Monte as the owners of this palace and records that the remains of Michelangelo's bastions at that point in the wall were in his day being used for ice houses (4, pp. 1390–1391). This corner of the walls was indeed adjacent to the Guardi property at La Mattonaia, but I have found no further documentation. On the bastion at Tre Canti, see Varchi, p. 682. The gallows would be moved there temporarily in 1530 at the end of the siege.

105 See [Cox-Rearick], 1989, pp. 30–33, for the views of Forster, Simon, and others that the building alludes to the occupation of the Florentine fortresses by Spanish troops after the assassination of Alessandro, and that it represents a proleptic fulfillment of Cosimo's desire to wrest them back. Cox-Rearick identified the building behind the *Halberdier* as the Fortezza da Basso in Florence, even though this green wall bears no resemblance whatsoever to the fortress's distinctive stone bosses. In 1537–38 Cosimo's rule depended entirely on Charles v, and it is unlikely that he would have challenged imperial authority in this way the very moment he assumed power. Cosimo's enemy Filippo Strozzi was imprisoned in the Fortezza da Basso after the Battle of Montemurlo, but the further proposal that the inexperienced young duke (still beardless) would have wished to be seen standing guard over his own elderly and revered prisoner is equally implausible. Strozzi committed suicide in prison in 1538.

106 See, for example, Polidori, pp. 390–391 n. a, for the assignment to the bastions of captains and militias as the "guardia del Monte" in connection with the decision to attack the enemy on 20 June 1530.

107 See also Barolsky, pp. 38–65, for the suggestion that, in connection with Dante's view that *nomina sunt consequentia rerum* (names are the consequences of things), Vasari's description of Mona Lisa's famous smile is also to be associated with her name: "La Gioconda" was the wife of Francesco del Giocondo. Leonardo's portrait of Cecilia Gallerani also engages in a pun on her name; see Schneider, pp. 54–55.

108 Cited by Trexler, p. 531. See also Rubinstein, p. 23.

109 Varchi, p. 290.

110 *L'Assedio*, p. 146. For the 1528 Provisions of the Consiglio Maggiore, which permitted the wearing of a feather or a hat badge, but no gold or silver cloth, see *Archivio storico italiano*, 1 (1842), pp. 397–409.

111 That the chain is already sketched in here is compelling evidence for a connection with the

Getty portrait, the only known male portrait by Pontormo in which such a chain appears. Cox-Rearick, 1964, 1, pp. 276–277, nos. 292–293, also dates the sheet circa 1530, but associates it with a hypothetical "lost" portrait of Francesco Guardi rather than the *Halberdier*. The figures bear no resemblance to the more flaccid, liquid forms found in drawings of circa 1537. If their connection to the Getty portrait is accepted, then it becomes even more difficult to move the portrait to 1537.

112 We should also reconsider the drawing on the recto of this Uffizi sheet, which shows a more ponderous, less gracefully tense figure. The ear is softer, the shoulders less exaggerated; the look is more experienced and cautious. The figure is not framed by a line, and there is no chain. The drawing style suggests a later moment, if indeed it is by Pontormo. I do not believe that this drawing is preparatory for the portrait of Francesco Guardi (i.e., the *Halberdier*), and it has only compromised understanding of the drawings on the verso, which it resembles very little. See now Falciani, 1996, pp. 87–88, who also accepts a date of circa 1535 for the later study on the recto.

113 Cox-Rearick, 1964, 1, p. 271, no. 288, identified this drawing as belonging to a group of red-chalk studies executed in the "ultrarefined red chalk manner of the Santa Felicità period [the later 1520s]." Apparently she abandoned this view in her 1989 identification of the *Halberdier* as Cosimo in 1537–38. Her redating, however, would make the drawing contemporary with studies for Pontormo's lost frescoes at the Medici villa at Castello. The elongated, Michelangelesque, and oddly proportioned figures in the latter, figures Vasari found "without measure and very strange," bear no relation to our portrait. Even allowing for the difference in genre, it is difficult to align this red-chalk drawing in purely technical terms with the soft, overly elaborated, black-chalk drawings for the loggia at Castello.

114 This has also been proposed by Falciani, 1996, pp. 84–85, who sees the weakness of the draw-

ing as more typical of a copy or variant, though without changing the attribution. If the drawing is some kind of copy or record, the chronological problems are the same. With characteristic insight, Berti, 1990, p. 44, finds it unlikely that a drawing of such a simple *soldatino* (toy soldier) could have been the starting point for a portrait of Cosimo.

115 Norman, pp. 36 (for quilions and side-rings), 56 (knobs on side-rings), 105–106 (the hilt), 241 (the lenticular pommel).

116 Norman, pp. 293–295, points to the Italian fashion for attaching the side-piece at the right hip, citing Lotto's *Portrait of a Man* in the Cleveland Museum of Art, circa 1525.

117 Vasari-Milanesi, 2, p. 403.

118 Shearman, 1967, esp. pp. 38, 53. See further Elias, p. 212, for criticism of the related distinction between the "inner," or, "true," content of a figure and his "outer appearance."

119 See Cropper, 1985, for the official double duel that took place outside the walls in March 1530 between members of the imperial and republican camps. Through such staged events, anachronistic feats of feudal honor in the midst of unrelenting misery, *virtù* might be preserved. It was the restoration of such *virtù* to war itself that Machiavelli hoped in vain to establish through the militias.

120 Trexler, p. 519 (for Alamanni) and p. 531 (for Nardi).

121 See Davitt Asmus, p. 23, for an explanation of the Sanvitale portrait as an *imago pulcher et deiformis tanquam in specula*, and for this citation from Francesco di Giorgio's *De harmonia mundi totius cantica tria* (Venice, 1525).

122 For other studies drawn by Pontormo after his own bodily image, probably with the help of a sheet of polished metal, see Del Bravo. See further Falciani, 1996. On the youthful beauty of Joseph in Rosso's *Marriage of the Virgin*, 1523, see Falciani, 1994.

123 Such extraordinary images also associate Pontormo with Albrecht Dürer's theomorphic (or,

godlike) self-images, for which see Koerner. On Dürer and Parmigianino in this sense, see Davitt Asmus, pp. 18–19.

124 Smyth, 1955, pp. 133–134.

125 It is worth noting that those who claim that the *Halberdier* is Cosimo I in 1537–38 would have us believe that Pontormo's adolescent sitter is also an eighteen-year-old.

126 Castiglione, pp. 120–121.

127 For the most complete discussion, see Dülberg, esp. pp. 31–98.

128 See ibid., p. 234, no. 179, for a portrait by Jan Gossaert, dated 1534, showing a finely dressed man on the obverse, and a grisaille image of Lucretia killing herself on the reverse.

129 The best-known pair is Lorenzo Lotto's 1505 portrait of *Bernardo de' Rossi* (34.4 × 42 cm, Museo di Capodimonte, Naples), and its allegorical cover (56 × 43 cm, National Gallery of Art, Washington). See ibid., pp. 238–239, no. 187; Pope-Hennessy, 1966, pp. 212–216.

130 Natali, pp. 117–137.

131 Cox-Rearick, 1964, 1, pp. 123–137, esp. p. 133, no. 48. Rejecting the connection with the *Pygmalion and Galatea*, she identifies instead as a model another black-chalk figure drawing on a sheet in use around 1532 ("even though the nude does not actually kneel in the drawing"); see pp. 275–276, no. 291. Shearman, 1972, p. 211, challenges this, also preferring the earlier Visdomini drawing as a source. See now Falciani, 1996, pp. 21–22, no. II.6, who also associates this earlier drawing by Pontormo with his pupil's composition.

132 Cox-Rearick, 1964, 1, pp. 163–164, no. 101. So conspicuous are these connections that some have argued for Pontormo's actual participation in the *Pygmalion and Galatea*. Close examination of the painting suggests otherwise.

133 The exact date of the marriage is unknown. For Diamante's baptism on 20 February 1538, see AOD, Registri dei Battezzati, Femmine 1533–42, fol. 86v. For her dowry, see ASF,

Monte Comune o delle Graticole 3754, fol. 9, and 3755, fol. 210. For the registration of Giovanni di Francesco's birth on 14 October 1539, see ASF, Cittadinaria, Quartiere S. Croce, filz. 3, fol. 45v. The five grandsons of Francesco's brother, Gherardo, are also registered here. See ASF, Notarile Antecosimiano 19882 (1551–54: not. Mario Tanci), fols. 107–108, 116, esp. 122r–125r, for property transactions relating to a gift from Francesco's mother-in-law, Margherita di Filippo Bardi, to his children, and identifying his wife as Selvaggia di Onofrio Cambini. My thanks to Elizabeth Pilliod for her generosity in passing on this last reference.

134 Berti, 1993, p. 168, also identified the landscape as the devastated land around Florence, though he misread the well as one of the battering rams used in the destruction of the suburbs.

135 *Trattati*, pp. 67–69.

136 Berti, 1990, p. 49, also suggests that the cover would have served to conceal Guardi's republican stance during the siege. The Guardi del Monte do not appear among those imprisoned, executed, or exiled after the surrender. Without seeking to embellish Francesco Guardi's actual heroism, we may recognize that the portrait could have been compromising nevertheless.

137 ASF, Comp. RS, 691, no. 6, fols. 44v, 45. He was nominated again in 1553, fol. 71v. My thanks to David Franklin for this reference.

138 Francesco's burial in Santa Croce on 16 September 1554 is recorded in ASF, Ufficiali della Grascia (Morti) 191, 503r, and Arte de' Medici e Speziali 251, p. 80r. See ASF, Not. antecos. 19883 (Mario Tanci, 1555), fols. 33r and 33v, 34r–35v (10 September 1554). The Guardi de' Monte also had a chapel at San Francesco al Monte, where their arms are still to be seen. For intervening tax information, see ASF, Decima Granducale 3594, fol. 99 (1547, 1548, 1551, 1552, 1553).

139 ASF, Not. antecos. 19883, fols. 33r and 33v, 44r–47r.

140 For the guardians, see ASF, Pupilli del Princi-
 pato, Campioni di Deliberazione 12, fol. 27v
 (14 December 1554), and fol. 53r (11 March
 1555).

141 ASF, Pupilli del Principato, Campioni di
 Deliberazione 12, fol. 27v (14 December 1554,
 7 January, 2 February 1555); fol. 53r (11 March,
 2, 9, 23, 30 April, 20 August, 6 September 1555);
 fol. 120r (29 October 1555, 24 January, 11 May,
 6 October 1556, 7, 22 January 1557); fol. 255,
 257v (21 September 1556). Campioni di Deli-
 berazione 13, 14v (25 September, 5, 26 Novem-
 ber 1557); fol. 40 (27 December 1557, 4, 18
 January, 30 August, 7 October 1558, 2 June,
 12 December 1559).

142 ASF, Decima Granducale 2379, fol. 152, gives
 the date of death as 15 May 1618. See Decima
 Granducale 2374, fol. 55, and 2378, fol. 143,
 for mention of land Francesco had bought at
 Concisa in 1544. The granducal tax records
 include further references to the Guardis'
 affairs, too numerous to cite here.

143 Ricci, pp. 13–14 (his inscription in the guard,
 for which one had to be noble and have the
 right to bear arms); p. 80 (gambling in the Via
 Larga, 1573); pp. 93–94 (punishment for gam-
 bling, 1574); pp. 112–113 (murder of Filippo
 Barducci and gambling, 1575); pp. 138–139
 (further on the murder, 1575); p. 200 (sent to
 Rome for trial, 1577); pp. 210–212 (confesses
 to having had Barducci murdered because of
 gambling debts, and is hanged on 18 April
 1577); pp. 238–239 (the suspicion that he had
 also drowned Alessandro Soderini). Simon,
 pp. 171–172 n. 2, draws attention to these
 charges, but in the context of his belief that
 the *Halberdier* represents Cosimo I.

144 For tax information on various of Francesco's
 brother Gherardo's children, see ASF,
 Decima Granducale 3597, fol. 337 (for Paolo,
 Gherardo, Andrea, and Attilio, 1618, 1619,
 1626); fol. 348 (for Paolo and Attilio, 1631);
 fol. 352 (Paolo di Francesco di Gherardo, 1649,
 1651).

145 Lensi Orlandini Cardini, p. 145. The property
 is now owned by the Uzielli.

146 Smyth, 155, p. 118. Smyth's perceptive analysis
 of the relationship between the two, and of
 the vital importance of Pontormo's master-
 piece for Bronzino, finds support in some new
 evidence. When a tracing of the *Halberdier* is
 superimposed on an X-radiograph of Bron-
 zino's *Young Man with a Book*, the outlines of
 the two figures in the crucial area of the head
 and shoulders correspond closely (and espe-
 cially so in the case of the first version of the
 Metropolitan picture). When a tracing of the
 Halberdier is superimposed on the portrait of
 Guidobaldo della Rovere, the outlines of head
 and shoulders also correspond. For a photo-
 graph of the Getty and Metropolitan portraits
 hanging side by side at the Metropolitan
 Museum, which already suggests this corre-
 spondence, see Cropper, in Florence, 1996,
 p. 76.

147 Ibid., p. 117. Smyth could not accept the date
 of 1535–40 that was earlier proposed for the
 finished version because the portrait is so dif-
 ferent in feeling, for example, from the por-
 traits of Ugolino Martelli and Bartolomeo
 Panciatichi.

148 The *Young Man with a Plumed Hat* by
 Bronzino, now in Kansas City.

149 Keutner, p. 152. ASF, Carte Riccardi 258,
 fol. 21v. The Getty portrait hung in the ninth
 lunette, the Piasecka Johnson portrait in the
 eleventh. Between them, in the tenth lunette,
 was a large *Leda and the Swan* by Puligo,
 flanked by a smaller *Leda* and a still-life of a
 Vase of Fruit. A door separates the tenth and
 eleventh lunettes.

150 [Cox-Rearick], 1989, p. 37.

151 Costamagna, pp. 242–244, no. 79. It should be
 noted that there is also no evidence that the
 original medium of the Piasecka Johnson por-
 trait is tempera.

152 Berti, 1990, p. 46.

153 The painted surface has been transferred
 twice, from panel to canvas and back. The
 panel has a rigid cradle, and the surface has
 been varnished in such a way as to render it

opaque. Expert opinion is that some original paint survives, but the face in particular has suffered at the hands of recent restoration. It is remarkable that no one detected the features of Cosimo before the association with the inventory.

154 For example, Forster, 1964, p. 380, observing the intimate relationship borne by the Piasecka Johnson portrait to such masterpieces as Bronzino's *Portrait of a Young Man with a Book* and *Portrait of Ugolino Martelli*, believed the Piasecka Johnson picture to be merely a variant of the *Halberdier* (which he accepted as a portrait of Cosimo I and dated to 1537–39), finding it so derivative that he attributed it to Bronzino's workshop and dated it to 1540–41.

155 [Cox-Rearick], 1989, p. 38. Before changing her mind about the identification, she agreed with Smyth that "there is no question that the *Young Man* was inspired by Pontormo's portrait [i.e., the *Halberdier*]," but she dated the first version of the Metropolitan picture to the early 1530s, after Bronzino's return from Pesaro. See Cox-Rearick, 1982, p. 70.

156 Alessandro Cecchi has suggested that it might be possible to identify the sitter in the Piasecka Johnson portrait with Carlo Neroni. Vasari mentions Neroni's portrait in connection with a version of the *Martyrdom of the Ten Thousand* painted for him, and adds that Pontormo portrayed *similmente*, at the time of the siege, Francesco Guardi dressed as a soldier. Neroni would have been eighteen in 1529–30. See Cropper, in Florence, 1996, p. 380, no. 142.

157 Cropper, 1985, p. 157.

158 The drawing, which has an old attribution to Pontormo, has recently been dismissed as a later sixteenth-century copy, which is unlikely. See Byam Shaw, 1, pp. 35–36, no. 27.

159 Monbeig Goguel, p. 349, proposed an attribution to Sebastiano Vini. Jacqueline Biscontin, who is studying the volume, has suggested Maso di San Friano.

160 As Forlani Tempesti, citing Pifferi, points out, however, Pontormo's work was engraved only rarely before the eighteenth century.

161 Costamagna, pp. 244–245, no. 79a. The author suggests that the work may have been executed by Bronzino's workshop (with the face by Pontormo!) on the basis of the cartoon used for the *Halberdier* and the Piasecka Johnson portrait. Again, the importance of the presumed sitter is made to account for the similarity, rather than a workshop practice of reusing an innovative design, passed on from master to pupil.

162 Berti, 1990, p. 47.

163 I asked this rhetorical question in a lecture at the J. Paul Getty Museum in 1991. The case has recently been made. Seeing various weaknesses in Cox-Rearick's and Costamagna's arguments, Simoncelli, pp. 505–507, proposes that the *Halberdier*'s costume resembles those worn by Machiavelli's republican militia in Florence in 1506: the portrait shows Cosimo dressed as a republican (to indicate his defense of Florence against external threat), and at night (to record the Battle of Montemurlo, which took place at night); the *Hercules and Antaeus* indicates Cosimo's struggles against enemies of the state. In this image of a "republican" Cosimo, writes Simoncelli, were vested the hopes of the oligarchy for a moderate principate, a new version of the republic of Capponi. This attempt to save the Cosimo identification involves jettisoning most of the arguments of its proponents.

BIBLIOGRAPHY

Most of these titles are cited in the notes. Others provide important information and should be consulted for further study.

ADEMOLLO

Ademollo, A. *Marietta de' Ricci ovvero Firenze al tempo dell'assedio: Racconto storico*. 6 vols. 2nd ed. With notes by L. Passerini. Florence, 1845.

AOD

Archivio dell'Opera del Duomo, Florence.

ASF

Archivio di Stato, Florence.

L'ASSEDIO

L'Assedio di Firenze illustrato con inediti documenti. Florence, 1840.

BAROLSKY

Barolsky, P. *Why Mona Lisa Smiles and Other Tales by Vasari*. University Park, Penn., 1991.

BAYLEY

Bayley, C. C. *War and Society in Renaissance Florence*. Toronto, 1961.

BERTI, 1966

Berti, L. "Precisazioni sul Pontormo." *Bollettino d'Arte* 51 (1966): 50–57.

BERTI, 1990

———. "L'*Alabardiere* del Pontormo." *Critica d'Arte* 55 (1990): 39–49.

BERTI, 1993

———. *Pontormo e il suo tempo*. Florence, 1993.

BNF

Biblioteca Nazionale, Florence.

BRACCIANTE

Bracciante, A. M. *Ottaviano de' Medici e gli artisti*. Florence, 1984.

BYAM SHAW

Byam Shaw, J. *The Italian Drawings of the Frits Lugt Collection*. 2 vols. Paris, 1983.

CAMPBELL

Campbell, L. *Renaissance Portraits: European Portrait-Painting in the Fourteenth, Fifteenth and Sixteenth Centuries*. New Haven, 1990.

CARTER

Carter, T. "*Non occorre nominare tanti musici*: Private Patronage and Public Ceremony in Late Sixteenth-Century Florence." *I Tatti Studies* 4 (1991): 89–104.

CASTIGLIONE

Castiglione, B. *The Book of the Courtier*. Trans. C. S. Singleton. Garden City, N.Y., 1959.

CELLINI, 1967

The Treatises of Benvenuto Cellini on Goldsmithing and Sculpture. Trans. C. R. Ashbee. New York, 1967.

CELLINI, 1985

Cellini, B. *Vita*. Ed. E. Camesasca. Milan, 1985.

CHASTEL

Chastel, A. *The Sack of Rome, 1527*. The A. W. Mellon Lectures in the Fine Arts. Bollingen Series 35:26. Princeton, 1983.

CLAPP

Clapp, F. M. *Jacopo Carucci da Pontormo: His Life and Work*. New Haven, 1916.

COSTAMAGNA

Costamagna, P. *Pontormo*. Milan, 1994.

COX-REARICK, 1964

Cox-Rearick, J. *The Drawings of Pontormo*. 2 vols. Cambridge, Mass., 1964.

COX-REARICK, 1981

———. *The Drawings of Pontormo*. 2 vols. Cambridge, Mass., 1981. [Reprint of 1964 edn. with appendix.]

COX-REARICK, 1984

———. *Dynasty and Destiny in Medici Art: Pontormo, Leo X, and the Two Cosimos*. Princeton, 1984.

[COX-REARICK], 1989

An Important Painting by Pontormo from the Collection of Chauncey D. Stillman. Sale cat. Christie's, New York. Wednesday, 31 May 1989.

COX-REARICK, 1993

———. *Bronzino's Chapel of Eleonora in the Palazzo Vecchio*. Berkeley, 1993.

CROPPER, 1985

Cropper, E. "Prolegomena to a New Interpretation of Bronzino's Florentine Portraits." In *Renaissance Studies in Honor of Craig Hugh Smyth*. 2 vols. Ed. A. Morrogh et al. Florence, 1985.

CROPPER, 1996

———. "Pontormo's *Halberdier*." *Center 16: Record of Activities and Research Reports, June 1995–May 1996*. National Gallery of Art Center for Advanced Study in the Visual Arts. Washington, D.C., 1996, pp. 75–78.

DAVITT ASMUS

Davitt Asmus, U. "Fontanellato I. Sabatizzare il Mondo: Parmigianinos Bildnis des Conte Galeazzo Sanvitale." *Mitteilungen des Kunsthistorischen Instituts in Florenz* 27 (1983): 3–39.

DEI

Dei, B. *La Cronica dall'anno 1400 all'anno 1500*. Ed. F. Papafava. Florence, 1984.

DEL BRAVO

Del Bravo, C. "Dal Pontormo al Bronzino." *Artibus et Historiae* 12 (1985): 75–87.

DE TOLNAY

De Tolnay, C. *Michelangelo*. Vol. 3, *The Medici Chapel*. Princeton, 1948.

DÜLBERG

Dülberg, A. *Privatporträts*. Berlin, 1990.

ELAM, 1993

Elam, C. "Art in the Service of Liberty: Battista della Palla, Art Agent to Francis I." *I Tatti Studies* 5 (1993): 33–109.

ELAM, 1994

———. "Lorenzo's Architectural and Urban Policies." In *Lorenzo il Magnifico e il suo mondo*. Ed. G. C. Garfagnini. Florence, 1994, pp. 357–384.

ELIAS

Elias, N. *The Civilizing Process: The History of Manners and State Formation and Civilization*. Trans. E. Jephcott. Oxford, 1994.

ETTLINGER

Ettlinger, L. "Hercules Florentinus." *Mitteilungen des Kunsthistorischen Instituts in Florenz* 16 (1972): 119–142.

FALCIANI, 1994

Falciani, C. "Il Rosso Fiorentino per Carlo Ginori." *Artista: Critica dell'arte in Toscana* 6 (1994): 8–25.

FALCIANI, 1996

———. *Pontormo: Disegni degli Uffizi*. Exh. cat. Gabinetto Disegni e Stampe degli Uffizi, no. 74, Florence, 1996.

FLORENCE, 1986

Andrea del Sarto 1486–1530: Dipinti e disegni a Firenze. Exh. cat. Palazzo Pitti, Florence, 1986.

FLORENCE, 1996

L'Officina della Maniera: Varietà e fierezza nell'arte fiorentina del Cinquecento fra le due repubbliche 1494–1530. Exh. cat. Galleria degli Uffizi, Florence, 1996.

FORLANI TEMPESTI

Forlani Tempesti, A. "Sfortuna del Pontormo nell'incisione." In *Pontormo e Rosso*. Ed. R. P. Ciardi and A. Natali. Venice, 1996, pp. 72–90.

FORSTER, 1964

Forster, K. W. "Probleme um Pontormos Porträtmalerei (I)." *Pantheon* 22 (1964): 376–384.

FORSTER, 1971

———. "Metaphors of Rule: Political Ideology and History in the Portraits of Cosimo de' Medici." *Mitteilungen des Kunsthistorischen Instituts in Florenz* 15 (1971): 65–104.

FRANKLIN

Franklin, D. *Rosso in Italy*. New Haven, 1994.

FREEDBERG, 1971

Freedberg, S. J. *Painting in Italy, 1500–1600*. Harmondsworth, 1971.

FREEDBERG, 1990

———. *Painting in Italy, 1500–1600*. 2nd ed. London, 1990.

GILBERT

Gilbert, F. *Machiavelli and Guicciardini: Politics and History in Sixteenth-Century Florence*. New York, 1965.

GINORI LISCI, 1953

Ginori Lisci, L. *Gualfonda: Un antico palazzo ed un giardino scomparso*. Florence, 1953.

GINORI LISCI, 1985

———. *The Palazzi of Florence: Their History and Art*. 2 vols. Trans. J. Grillo. Florence, 1985.

GOLDTHWAITE, 1968

Goldthwaite, R. *Private Wealth in Renaissance Florence: A Study of Four Families*. Princeton, 1968.

GOLDTHWAITE, 1980

———. *The Building of Renaissance Florence: An Economic and Social History*. Baltimore, 1980.

GREENBLATT

Greenblatt, S. J. *Renaissance Self-Fashioning: From More to Shakespeare*. Chicago, 1980.

HACKENBROCH

Hackenbroch, Y. *Renaissance Jewellery*. London, 1979.

HALE

Hale, J. *Artists and Warfare in the Renaissance*. New Haven, 1990.

HARE

Hare, C. *The Romance of a Medici Warrior*. New York, 1910.

HAYUM

Hayum, A. "Michelangelo's *Doni Tondo*: Holy Family and Family Myth." *Studies in Iconography* 7–8 (1981–82): 209–251.

JONES

Jones, R. D. *Francesco Vettori: Florentine Citizen and Medici Servant*. London, 1972.

KEUTNER

Keutner, H. "Zu einigen Bildnissen des frühen Florentiner Manierismus." *Mitteilungen des Kunsthistorischen Instituts in Florenz* 7, Bd. 2 (1955): 139–154.

KOERNER

Koerner, J. L. *The Moment of Self-Portraiture in German Renaissance Art*. Chicago, 1993.

LANDUCCI

Landucci, L. *Diario fiorentino dal 1450 al 1516 continuata da un anonimo fino al 1542*. Reprint. Florence, 1985.

LANGDON

Langdon, G. "Pontormo and Medici Lineages: Maria Salviati, Alessandro, Giulia, and Giulio de' Medici." *RACAR* 19:1–2 (1992): 20–40.

LANGEDIJK

Langedijk, K. *The Portraits of the Medici: Fifteenth–Eighteenth Centuries*. 3 vols. Florence, 1981–1987.

LAPINI

Lapini, A. *Diario Fiorentino dal 252 al 1596*. Ed. G. O. Corazzini. Florence, 1900.

LAVIN, I.

Lavin, I. "An Observation on 'Medievalism' in Early Sixteenth Century Style." *Gazette des Beaux-Arts* 50 (1957): 113–118.

LAVIN, M. A.

Lavin, M. A. *Seventeenth-Century Barberini Documents and Inventories of Art*. New York, 1975.

LENSI ORLANDINI CARDINI

Lensi Orlandini Cardini, G. C. *Le Ville di Firenze*. Vol. 2, *Di la d'Arno*. Florence, 1955.

MACHIAVELLI

Opere di Niccolò Machiavelli. Ed. E. Raimondi. Milan, 1966.

MALANIMA

Malanima, P. *I Riccardi di Firenze: Una famiglia e un patrimonio nella Toscana dei Medici*. Florence, 1977.

MANETTI

 Manetti, R. *Michelangiolo: Le Fortificazioni per l'Assedio di Firenze*. Florence, 1980.

MASTERPIECES OF PAINTING

 Masterpieces of Painting in the J. Paul Getty Museum. 3rd ed. Malibu, 1995.

MATHER

 Mather, F. J. "The Halberdier by Pontormo." *Art in America* 10 (1922): 66–69.

McCORQUODALE

 McCorquodale, C. *Bronzino*. London, 1981.

MONBEIG GOGUEL

 Monbeig Goguel, C. "De Vérone à Florence: Sebastiano Vini dessinateur autour du 'Martyre des dix-mille.'" In *Kunst des Cinquecento in der Toskana*. Ed. M. Cämmerer. Munich, 1992.

NATALI

 Natali, A. *La Piscina di Betsaida: Movimenti nell'arte fiorentina del Cinquecento*. Florence and Siena, 1995.

NORMAN

 Norman, A. V. B. *The Rapier and Small-Sword, 1460–1820*. New York, 1980.

PILLIOD

 Pilliod, E. "The Earliest Collaborations of Pontormo and Bronzino: The Certosa, the Capponi Chapel, and the *Dead Christ with the Virgin and Magdalen*." In *The Craft of Art*. Ed. A. Ladis and C. Wood. Athens, Georgia, 1995.

PINELLI

 Pinelli, A. "'Pensando a nuove cose': Spunti per un analisi formale del linguaggio Pontormesco." In *Pontormo e Rosso*. Ed. R. P. Ciardi and A. Natali. Venice, 1996, pp. 52–61.

POLIDORI

 Polidori, F. "'Nota al Documento Quinto,' and the Publication of the *Provvisione della Milizia ed Ordinanza Fiorentina (6 Novembre 1528)*. In *Archivio storico italiano* 1 (1842): 384–409.

POLIZZOTTO

 Polizzotto, L. *The Elect Nation: The Savonarolan Movement in Florence, 1494–1545*. Oxford, 1994.

POPE-HENNESSY, 1966

 Pope-Hennessy, J. *The Portrait in the Renaissance*. The A. W. Mellon Lectures in the Fine Arts. Bollingen Series 35:12. Princeton, 1966.

POPE-HENNESSY, 1993

 ———. *Donatello, Sculptor*. New York, 1993.

RICCI

 Ricci, G. de'. *Cronaca (1532–1606)*. Ed. G. Sapori. Documenti di Filologia, 17. Milan, 1972.

ROCKE

 Rocke, M. *Forbidden Friendships: Homosexuality and Male Culture in Renaissance Florence*. New York, 1996.

ROTH

 Roth, C. *The Last Florentine Republic*. London, 1925.

RUBIN

 Rubin, P. *Giorgio Vasari: Art and History*. New Haven, 1995.

RUBINSTEIN

 Rubinstein, N. "Firenze tra repubblica e principato e i ritratti dei Medici del Pontormo." In *Pontormo e Rosso*. Ed. R. P. Ciardi and A. Natali. Venice, 1996, pp. 18–25.

SCHEVILL

 Schevill, F. *Medieval and Renaissance Florence*. 2 vols. New York, 1963.

SCHNEIDER

 Schneider, N. *The Art of the Portrait*. Cologne, 1994.

SHEARMAN, 1967

 Shearman, J. *Mannerism*. Harmondsworth, 1967.

SHEARMAN, 1972

 ———. "Review of J. Cox-Rearick, *The Drawings of Pontormo*." *Art Bulletin* 54 (1972): 209–212.

SIMON

 Simon, R. B. "Bronzino's Portraits of Cosimo de' Medici." Ph.D. diss., Columbia University, 1982.

SIMONCELLI

 Simoncelli, P. "Pontormo e la cultura

fiorentina." *Archivio storico italiano* 565 (1995): 487–527.

SMYTH, 1955

Smyth, C. H. "Bronzino Studies." Ph.D. diss., Princeton University, 1955.

SMYTH, 1992

———. *Mannerism and Maniera*. With an introduction by E. Cropper. 2nd ed. Vienna, 1992.

STEINBERG

Steinberg, L. "Pontormo's Alessandro de' Medici, or, I Only Have Eyes for You." *Art in America* 63 (1975): 62–65.

STEPHENS

Stephens, J. N. *The Fall of the Florentine Republic, 1512–1530.* Oxford, 1983.

STREHLKE

Strehlke, C. B. "Pontormo, Alessandro de' Medici, and the Palazzo Pazzi." *Bulletin — Philadelphia Museum of Art* 81 (1985): 3–15.

TRATTATI

Trattati d'arte del Cinquecento: Fra Manierismo e Controriforma. Vol. 1. Ed. P. Barocchi. Bari, 1960.

TRENTI ANTONELLI

Trenti Antonelli, M. G. "La Visitazione di Carmignano." In *Il Pontormo, Le Opere di Empoli, Carmignano e Poggio a Caiano. La Maniera moderna in Toscana.* Ed. R. Martignoni. Venice, 1994.

TREXLER

Trexler, R. *Public Life in Renaissance Florence.* 2nd edn. Ithaca and London, 1991.

VARCHI

Varchi, B. *Storia Fiorentina.* Vol. 1. *Opere di Benedetto Varchi.* Biblioteca Classica Italiana, secolo VI, no. 6. Trieste, 1858.

VASARI-MILANESI

Vasari, G. *Le Vite de' più Eccellenti Pittori, Scultori ed Architetti.* 11 vols. Ed. G. Milanesi. Florence, 1906.

WASSERMAN

Wasserman, J. "*La Vergine e Cristo con Sant' Anna* del Pontormo." In *Kunst des Cinquecento in der Toskana.* Ed. M. Cämmerer. Munich, 1992.

WRIGHT, A.

Wright, A. "The Myth of Hercules." In *Lorenzo il Magnifico e il suo mondo.* Ed. G. C. Garfagnini. Florence, 1994, pp. 323–339.

WRIGHT, D. R.

Wright, D. R. "The Medici Villa at Olmo di Castello: Its History and Iconography." Ph.D. diss., Princeton University, 1976.

ZÖLLNER

Zöllner, F. "Leonardo's Portrait of Mona Lisa del Giocondo." *Gazette des Beaux-Arts* 121 (1993): 115–138.

GENEALOGY OF THE GUARDI FAMILY

ACKNOWLEDGMENTS

Many friends and colleagues have helped to make this a better book. In Florence I have benefited from the generosity of Annamaria Petrioli Tofani, Alessandro Cecchi, Antonio Natali, and Carlo Falciani in particular. Nicoletta Baldini, Gabriella Battista, Edward Goldberg, Samuel K. Cohn, and Paola Peruzzi came to my help in the archives. Both David Franklin and Elizabeth Pilliod volunteered important documentary references and have followed the development of my story with true scholarly interest. Nicolai Rubinstein shared his ideas early on. Serena Padovani, Ezio Buzzegoli, Diane Kunzelmann, and Muriel Vervat introduced me to important questions raised in the course of conservation of other works by Pontormo and Bronzino in Florence. Marchese Lorenzo Bartolini-Salimbeni and Conte Niccolò Capponi graciously made their family archives available, sharing their own deep knowledge of the period in ways that bring the history of Florence alive. Philippe Costamagna, while disagreeing with my conclusions, has always been ready to discuss a point. Joaneath Spicer, Melanie Gifford, Giorgio Bonsanti, Pierre Rosenberg, Catherine Monbeig Goguel, and Keith Christiansen all helped me to see works of art under their care in special conditions. Much of the writing and research for this book was accomplished at the Center for Advanced Study in the Visual Arts at the National Gallery of Art in Washington, D.C., where I was Andrew W. Mellon Professor from 1994 to 1996. To Earl A. Powell III, Director of the National Gallery, and Dean Henry Millon and his staff at CASVA I owe a very special debt of gratitude. Pauline T. Maguire provided invaluable help in finding illustrations. Elena Calvillo, Carl Strehlke, Joseph J. Rishel, Giancarla Periti, Dorothée Puccini, Louise Lippincott, W. F. Kent, Dawson Carr, Sabine Eiche, Malcolm Campbell, David A. Brown, and David Jaffé have all provided information, criticism, and advice when called for. In the Department of the History of Art at Johns Hopkins University my colleagues have been supportive throughout. The Villa Spelman in Florence provided a home during part of my research, and a forum for discussion of the issues. George Goldner first persuaded me to think about this deeply controversial and unforgettable work of art. When he invited me to lecture at the Getty Museum on the newly acquired portrait in 1990, he set me off on a journey that I think neither of us could have predicted. In the Department of Publications at the J. Paul Getty Museum Benedicte Gilman provided intelligent support at a crucial moment. Craig Hugh Smyth has been an inspiration, always asking questions that might lead to greater clarity and greater complexity at the same time. Without Charles Dempsey this story about Florence and a portrait might never have been told.—E.C.

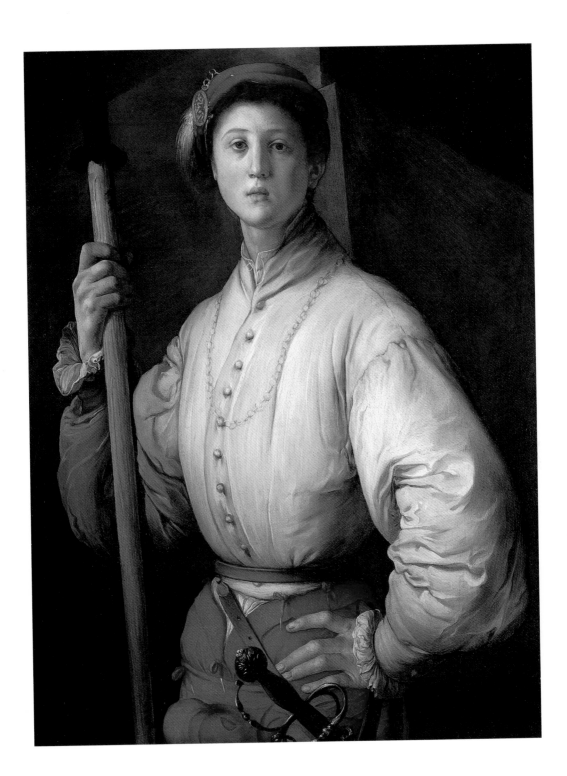